BEFORE THEIR TIME
THE WORLD OF CHILD LABOR

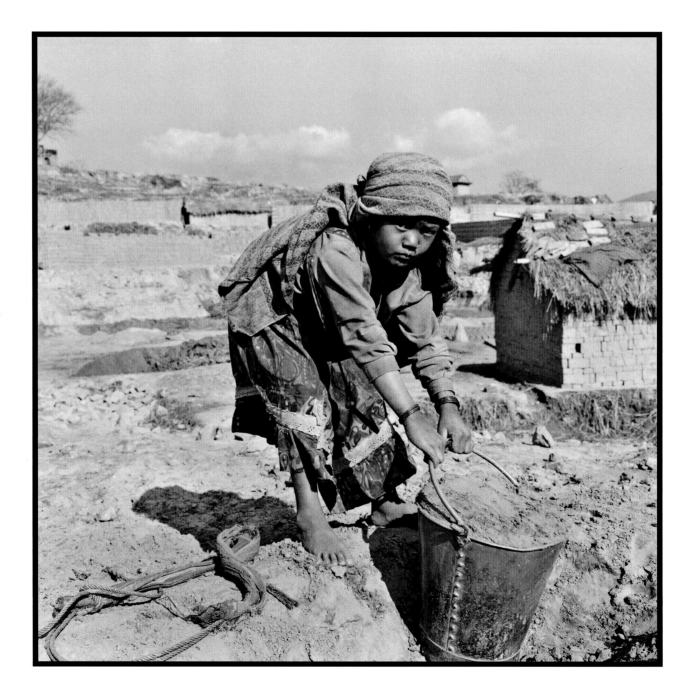

BEFORE THEIR TIME

THE WORLD OF CHILD LABOR

BY DAVID L. PARKER
FOREWORD BY SENATOR TOM HARKIN

THE QUANTUCK LANE PRESS NEW YORK

FOR YOUNG, PAUL, EDDIE, ANDREW, OLIVER, AND MADELEINE.
YOU ARE ALL MORE WONDERFUL BY THE YEAR.

4

BEFORE THEIR TIME: THE WORLD OF CHILD LABOR · DAVID L. PARKER
COPYRIGHT © 2007 BY DAVID L. PARKER
FOREWORD © 2007 BY SENATOR TOM HARKIN

ALL RIGHTS RESERVED · PRINTED IN ITALY · FIRST EDITION

LIBRARY OF CONGRESS CATALOGING-IN-PUBLICATION DATA

PARKER, DAVID L. (DAVID LEWIS), 1951–
 BEFORE THEIR TIME: THE WORLD OF CHILD LABOR / DAVID L. PARKER;
FOREWORD BY SENATOR TOM HARKIN. — 1ST ED.

 P. CM.
ISBN-13: 978-1-59372-024-7
1. CHILD LABOR. 2. CHILD LABOR — PICTORIAL WORKS. I. TITLE.
HD6231.P365 2007
331.3'1 -- DC22

 2007006402

LAYOUT AND COMPOSITION BY JOHN BERNSTEIN DESIGN, INC.
MANUFACTURED BY MONDADORI PRINTING
PRINTED IN ITALY

THE QUANTUCK LANE PRESS · NEW YORK
WWW.QUANTUCKLANEPRESS.COM

DISTRIBUTED BY:
W. W. NORTON & COMPANY, 500 FIFTH AVENUE, NEW YORK, NY 10110
WWW.WWNORTON.COM

W. W. NORTON & COMPANY LTD., CASTLE HOUSE, 75/76 WELLS STREET, LONDON, WIT 3QT

1 2 3 4 5 6 7 8 9 0

frontispiece: Laborer, Nepal, 1995

CONTENTS

FOREWORD
BY SENATOR TOM HARKIN 6

INTRODUCTION 8

AGRICULTURE AND HUSBANDRY 30

MINES AND STONE QUARRIES 50

BRICK WORKERS 66

TEXTILES AND OTHER MANUFACTURING 82

STREET WORKERS 108

GARBAGE PICKING AND BEGGING 138

THE FUTURE 160

ACKNOWLEDGMENTS 164

M Y FRIEND KAILASH SATYARTHI, director of the South Asian Coalition on Child Servitude, introduced me to Dr. Parker's work in the mid-1990s. At the time, I was trying to raise public awareness of child labor, and Kailash was assisting Dr. Parker in his work photographing child laborers in India and elsewhere in South Asia. After I learned of Dr. Parker's work, we arranged for the United States Senate and Department of Labor to exhibit his photographs.

A physician specializing in occupational health and safety, Parker has photographed children working in a wide range of industries in Mexico, Thailand, Nepal, Bangladesh, Turkey, Morocco, Indonesia, India, Peru, Ecuador, and other parts of the world. His photographs are intimate, respectful, and engaging. They bridge the distance between the viewer and the child. His work has been criticized for portraying children smiling and laughing as they labor; in fact, Parker depicts these children in their full humanity. Because his photographs make us identify with the children, we realize our responsibility to act.

These photographs are both eloquent and captivating. One haunting and engrossing series of images captures children working in garbage dumps. These are places where children scavenge alone or with their parents for anything they might sell or eat. The photographs confront us with the intolerable reality that in many parts of the world, large numbers of children live on top of rotting garbage, eat contaminated food, and do not have potable water to drink.

In an image of a child soldier in Sierra Leone, Parker captures a severe expression and a scarred face that do not belong on a boy of that age. The young soldier is holding a knife to his throat, as if his own life holds no value. This is a frightening photograph, an image that makes me wonder whom he has killed or mutilated. And who forced him. And who trained him. We would all prefer to turn

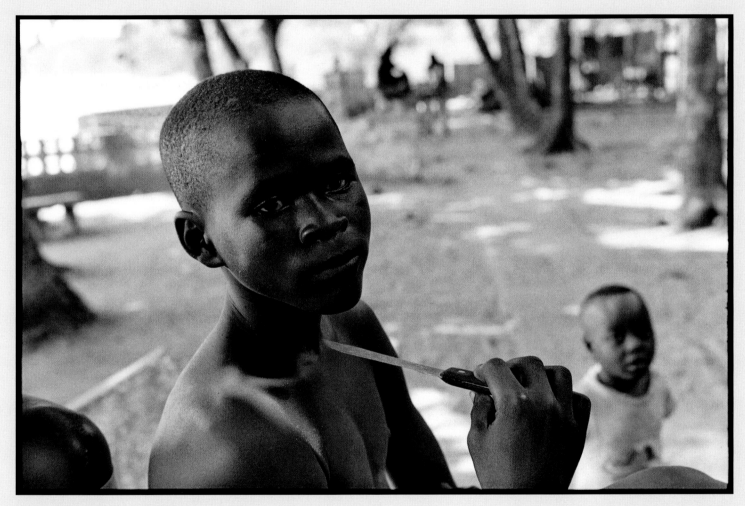

1. Child combatant, Sierra Leone, 2000

FOREWORD

away, but these photographs and the issues they reflect persist.

I have seen how photographs can raise questions and bring truth to light. As a young Congressional staffer in 1970, I participated in a fact-finding mission in Vietnam. I photographed South Vietnamese political prisoners in "tiger cages"— shackled and living in squalor. When I returned to the United States, I spoke out, despite my superiors' objections. My photographs of the prisoners were published in *Life* magazine. I was fired for insubordination, but I never regretted making those photographs public. Having taken them, it was my duty to speak up.

The work of photographer Lewis Hine also demonstrated the power of documentary photography. In the early twentieth century, Hine understood that disseminating images of child labor in America would help mobilize support for social reform. "Perhaps you are weary of child labor pictures," Hine said. "Well, so are the rest of us, but we propose to make you and the whole country so sick and tired of the whole business that when the time for action comes, child labor pictures will be records of the past." His photos helped bring about some of the most important labor reforms in modern American history.

The history of child labor provides hope for such change, but also the specter of unmet promises. The campaign against child labor is not new. Child labor has existed through the ages, and compassionate people have no doubt always worked to assist those caught in its throes. As new ideas emerged about children's rights during the Industrial Revolution, a growing number of people in the United States, Great Britain, and other countries called attention to the detrimental effects for children of working long hours in dangerous conditions. This eventually led to the control and near elimination of the most abusive forms of child labor in these nations.

Lewis Hine was followed by a long line of social documentary photographers such as Dorothea Lange, Robert Capa, W. Eugene Smith, and Gordon Parks. Parker's work continues this long and accomplished tradition of social reformers who have used the camera to document the lives of those invisible to a privileged society and to advocate for change. As Dr. Martin Luther King, Jr., said, "The arc of history is long, but it bends toward justice." It doesn't bend by itself, however; it takes persistent work by individuals like Dr. David Parker.

—SENATOR TOM HARKIN

WHEN I BEGAN PHOTOGRAPHING child labor in 1992, I had no idea how many children worked, what their working conditions were like, or how difficult it would be to document the issue. Although many factories and workplaces were open and easy to photograph, others were closed and unwelcoming. To gain entry into some factories, I presented myself as a buyer of shirts, carpets, or other products for an international corporation with only a post office box for an address.

I was surprised at what lay just beyond the surface of everyday activity. In 1993, during my first trip to Nepal, I visited dozens of carpet factories where children were hand-knotting carpets in cramped, musty rooms. After leaving Nepal, I went to Bangladesh and photographed children working waist deep in leather-tanning chemicals and scavenging plastic and cardboard amid the rotting waste in garbage dumps.

The photographs in this book portray the range of work and working conditions of children around the world. In a larger sense, this book documents an ongoing failure to meet children's basic needs—a goal that is clearly out of reach of their families. I have no doubt that poverty forces most working children and their families to become victims of economic exploitation. Some of these situations, such as sex trafficking, make regular news headlines. But problems such as lack of schools and lack of jobs in which parents can earn enough money to feed a small family go largely unnoticed.

Seeking to protect children from what are often deplorable working conditions, national and international communities have implemented laws and treaties to regulate child labor. Since the United Nations General Assembly adopted the

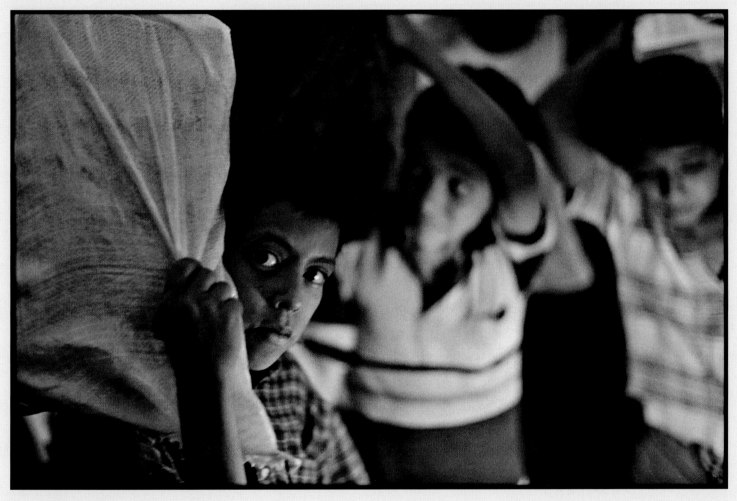

2. Smuggling contraband, Nicaragua, 2004

INTRODUCTION

Universal Declaration of Human Rights in 1948,[1] dozens of international treaties concerning children's rights have been written.

The most encompassing of these is the UN's 1989 Convention on the Rights of the Child, which recognizes every child's right to a primary school education. The convention also requires that nations protect children from economic exploitation "and from performing any work that is likely to be...harmful to the child's health or physical, mental, spiritual, moral or social development."

Another important treaty, the International Labour Office's Prohibition and Immediate Action for the Elimination of the Worst Forms of Child Labor, known as Convention 182, took effect in 1999. The International Labour Office (ILO), a branch of the United Nations, brings governments, workers, and employers together to promote safer and healthier working conditions. Convention 182 defines the worst forms of work as those associated with slavery and bondage, prostitution and pornography, illicit activities such as the drug trade, and other work that "is likely to harm the health, safety, or morals of children."[2]

In spite of numerous laws and treaties, child labor remains an enormous problem, and millions of children lack access to basic education. Officially, more than 320 million children under age sixteen work worldwide and 25 percent of children do not complete a primary school education. In addition, almost 150 million children labor in the worst forms of work as defined by the ILO.

I have sometimes found it difficult to define when work is harmful, in part because of the importance of education in all children's lives. Any job, even one that does not seem harmful, can keep a child from attending school. Education provides a basis for a child's social, economic, and cultural development as well as the foundation for a healthy life. Children whose parents—particularly their

mothers—are better educated are more likely to go to school and stay in school longer than children whose parents received little or no education. Further, children with less-educated mothers are more likely to work at an earlier age than children with educated mothers.

For many families, child labor is part of an intergenerational cycle of poverty, social exclusion, and lack of education. Poor families frequently lack the resources to ensure that their children go to school and stay healthy. An increased risk of illness contributes to the cycle of poverty. Young women who work and go to school or who work instead of attending school tend to have less-healthy children. A woman who has been to school for even a few years is more likely to marry later, obtain prenatal care, have a smaller family, and have healthier, better-educated children.[3]

Another difficulty in understanding when work is harmful stems from the complexity or ambiguity of some job circumstances. For example, in 1993 and 1995 I photographed circus performers in Nepal and India [PLATES 13, 14, 15, & 16]. Although the children are often laughing and having fun, most are bonded laborers, a type of modern-day slave. Circus owners trick families into selling their children and then force them to work many years without pay. Neither the poor working conditions nor the slavery-like situation is obvious to a casual observer.

Other forms of work harm children in much more obvious and painful ways. In 2000, I photographed children at a rehabilitation center for young combatants in Sierra Leone [PLATES 1 & 4]. The children told stories of being drugged and forced to kill their parents or mutilate their neighbors. They also reported being shot during combat or beaten if they tried to escape from military service.

Some domestic workers are held in virtual slavery behind locked doors.

13

Although I have photographs of children doing domestic chores—preparing food [PLATE 3], caring for sisters and brothers [PLATES 5 & 7], and washing clothes [PLATE 6]—only once did I gain access to a private home where children were employed. The employer did not allow me to take photographs.

Overall, working conditions for most children are pathetic. Many work sites lack sanitary facilities and clean drinking water. Child workers are exposed to excessive noise, clouds of dust, and other safety hazards. They eat food they find on the street or in the garbage dump, drink water and bathe in the same pond where they wash their tools and mix mud for making bricks, and live on the street or in cardboard huts.

Because children are still developing physically and mentally, harmful substances have a greater impact on them than on older workers. Pound for pound, children breathe more air, eat more food, and drink more water than adults do. Toxic chemicals such as mercury or lead can cause brain damage and permanent disabilities.

Children work long hours with little time for rest, play, or school, and even jobs that seem relatively safe place children at risk. Street vendors may leave for work at four or five a.m. and not return home until late at night. They go long stretches without eating. They may be robbed or abused. Street children often work for unscrupulous adults who refuse to pay them, cheat them of their earnings, or sexually exploit them.

Children who work face a wide array of dangers, from rats, wild dogs, and rotting wastes in garbage dumps [PLATE 8] and choking dust in stone quarries [PLATE 47] to injuries from high-speed machinery [PLATE 63] or the harsh chemicals used to tan leather [PLATE 66]. Some children develop diseases typically associated

with adults, such as arthritis or skin diseases [PLATE 78]. Most children do not wear protective equipment [PLATE 64]. Even when such equipment is provided, it does not serve children well since it is designed for adults.

I am encouraged by new data indicating that the number of working children around the world has declined over the past few years. Some nations have made strides to protect child workers from dangerous conditions, yet many others still fail to keep children safe, healthy, and educated.

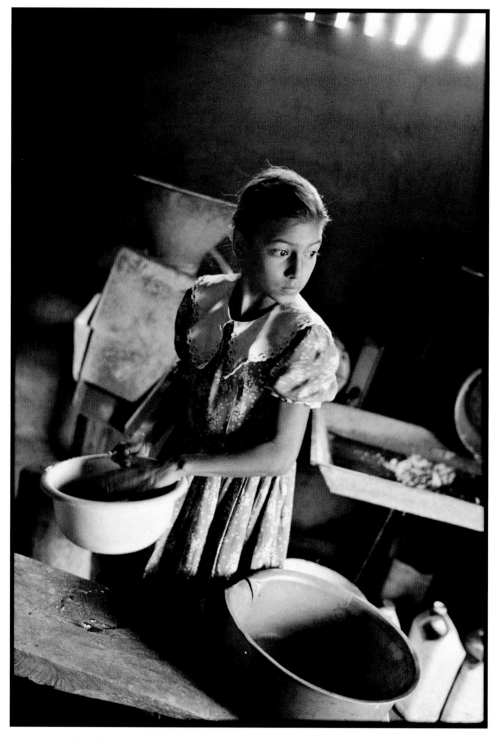

16

3. Home worker, Nicaragua, 2004

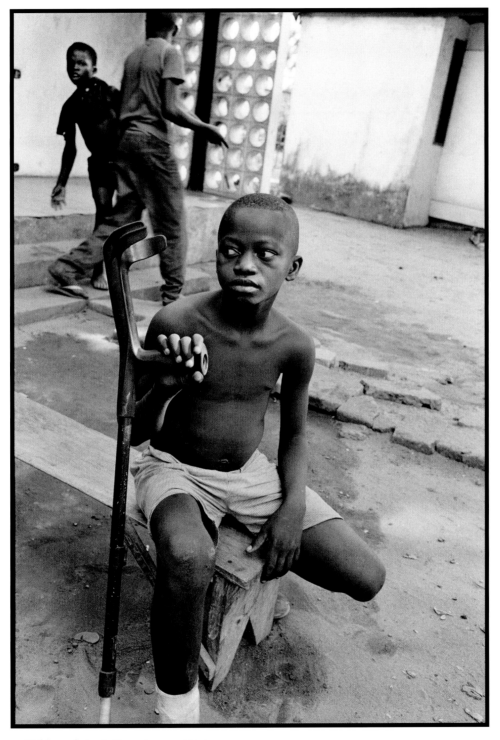

4. Child combatant, Sierra Leone, 2000

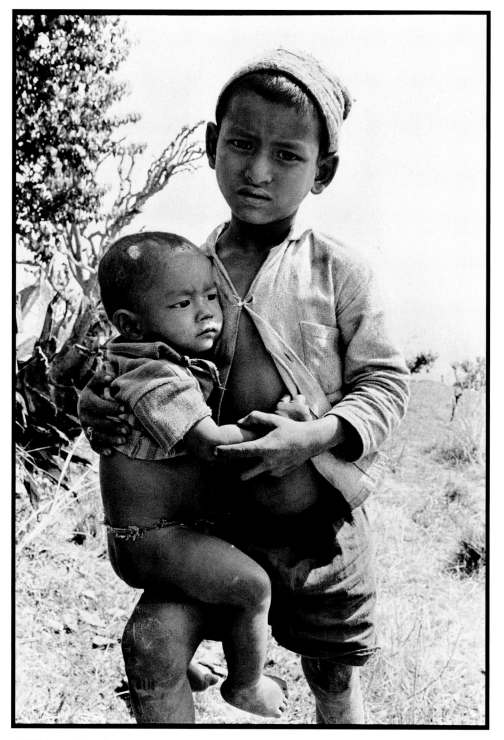

18

5. Child care, Nepal, 1993

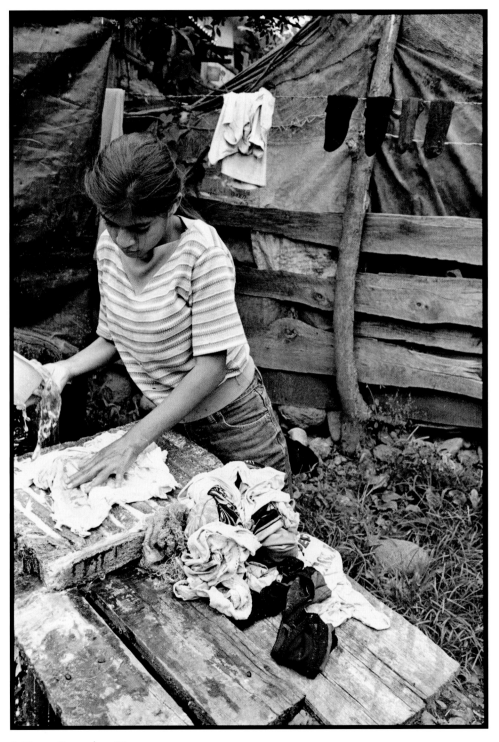

6. Domestic worker, Nicaragua, 2004

19

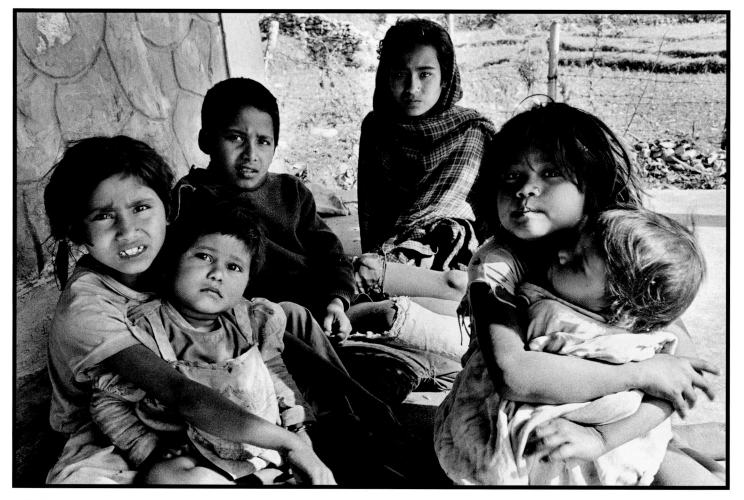

7. Child care, Nepal, 1993

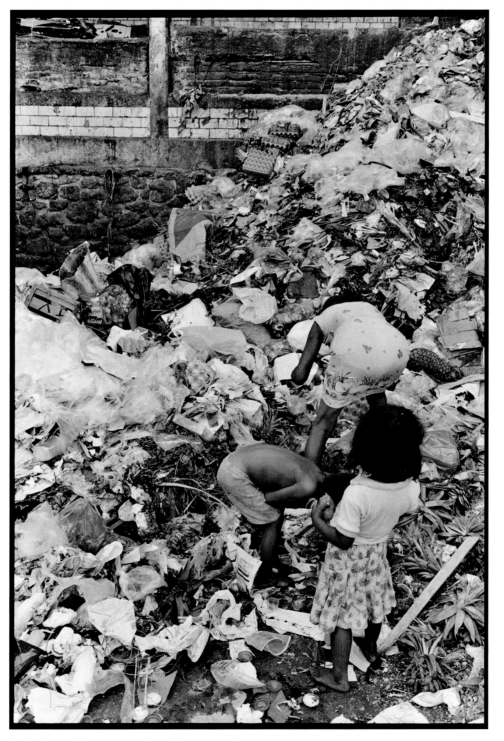

8. Garbage pickers in a market, Mexico, 1996

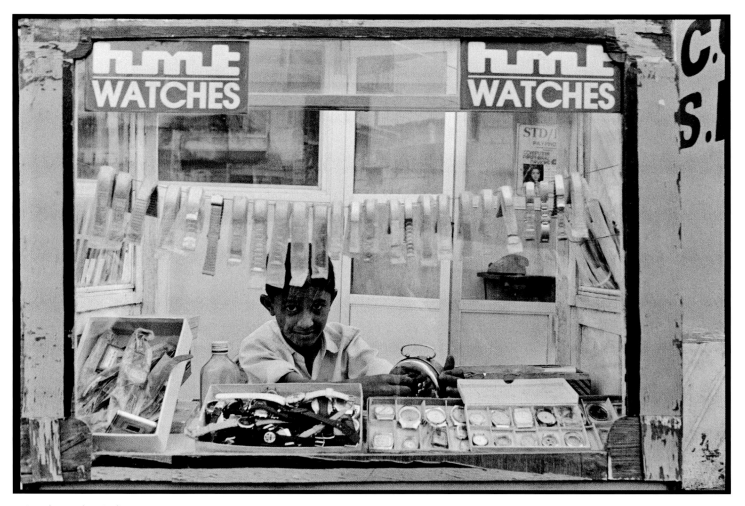

9. Jewelry worker, India, 1993

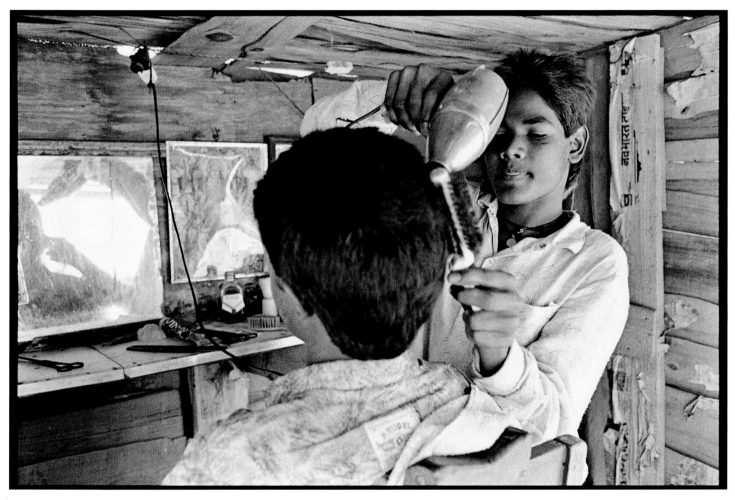

10. Barber, India, 1993

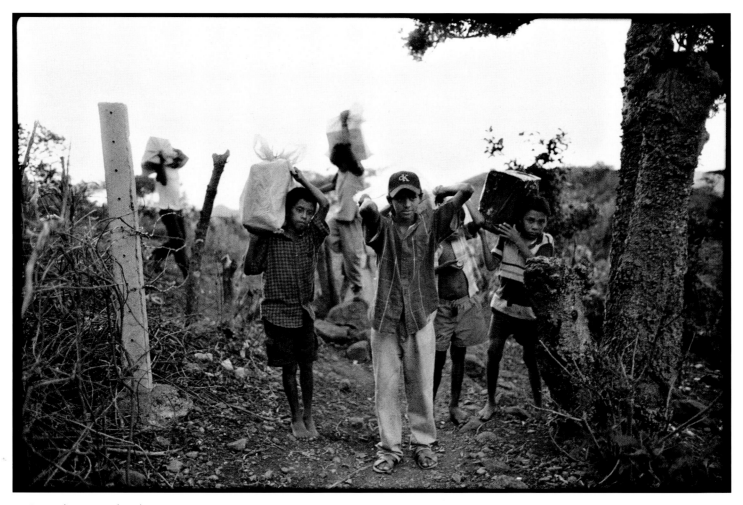

11. Smuggling contraband, Nicaragua, 2004

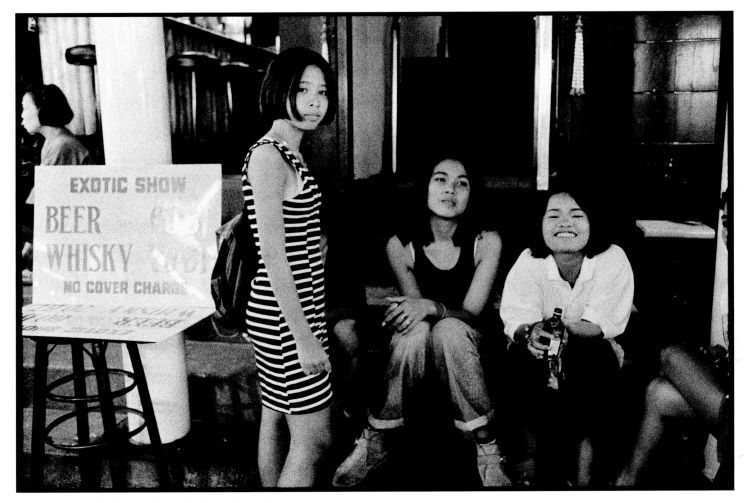

12. Sex workers drinking in front of a brothel, Thailand, 1993

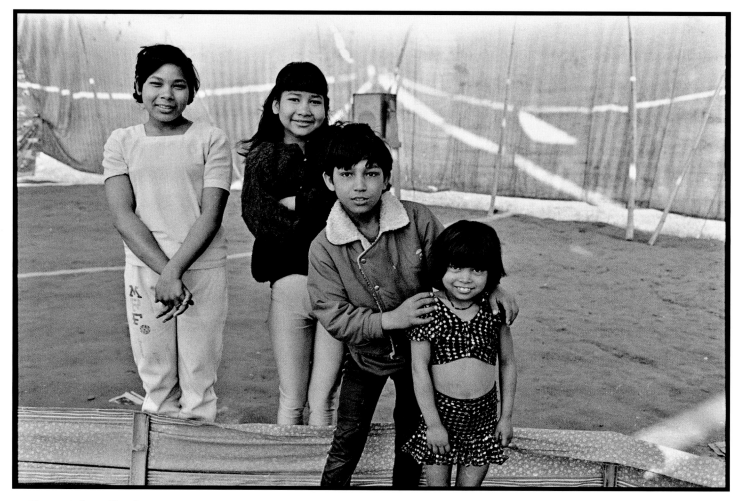

13. Circus workers, Nepal, 1993

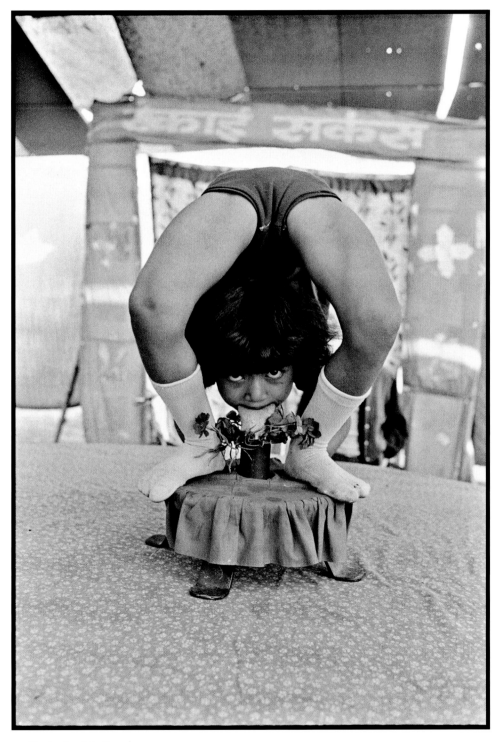

14. Contortionist, Nepal, 1993

28

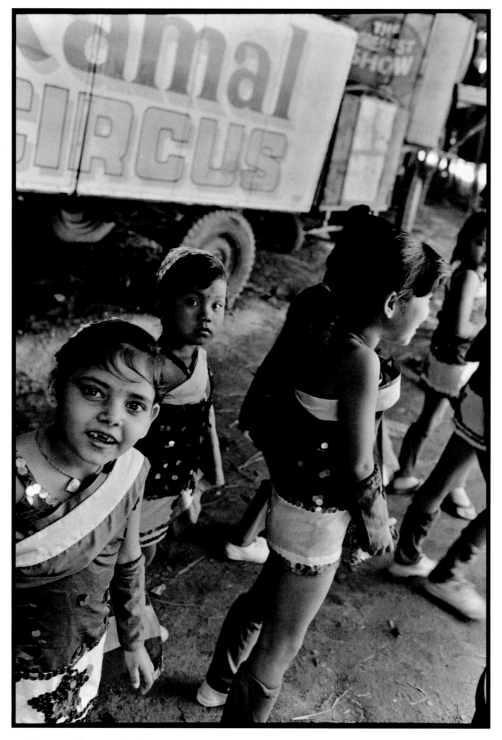

15. Circus performers, India, 1995

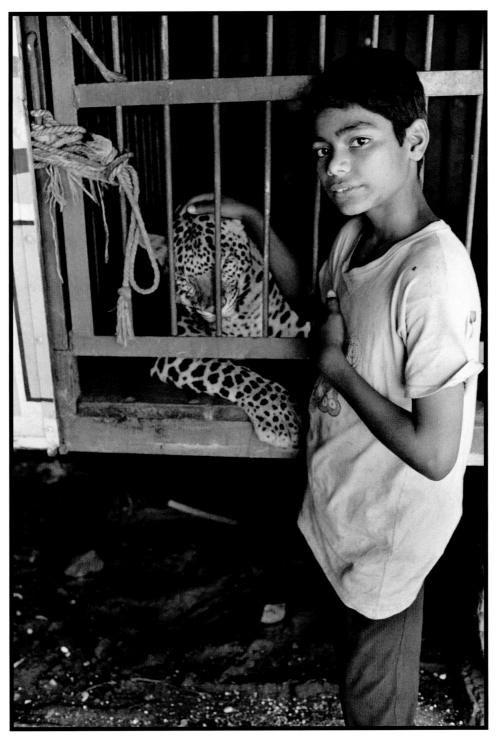

16. Circus worker, India, 1995

MORE CHILDREN WORK in agriculture than in any other industry. In some nations up to one-third of agricultural workers are children.[4] The popular image of a child on a farm is that of someone playing happily in a haystack. Most people wrongly assume that farmwork is healthy and that children who work on farms are part of a family business.

In reality, agricultural work is fraught with hazards, including chemical pesticides, large machinery, venomous insects and reptiles, unsafe drinking water, and parasitic diseases from contaminated irrigation water. Children on farms, plantations, and fisheries work long hours doing heavy, exhausting work. They plow fields with tractors or oxen, pick vegetables, cotton, fruits, and grains, and dive for shellfish. Children work in fields that have just been sprayed with pesticides. They work all day under the beating sun. Some labor as slaves on cocoa plantations.

During a recent trip to Nicaragua, I visited tobacco plantations. Children working in these fields are exposed to high levels of nicotine, which is absorbed through the skin and causes nausea and vomiting. The children also experience pesticide poisoning, with similar effects. Living conditions on plantations are poor: a dozen or more men, women, and children typically share a small room with no running water.

In many countries, large migrant communities follow the agricultural seasons from one region to another. In the United States, migrants may start the year in Texas and gradually work their way to the sugar beet fields in Minnesota's Red River Valley or the vegetable canning plants in southern Minnesota.[5] In Turkey, entire communities move from the eastern part of the country to central Anatolia to pick cotton [PLATE 27], dig potatoes, or harvest vegetables. Common to all migrant communities are low wages, unhealthy sanitary facilities, and meager opportunities for education.

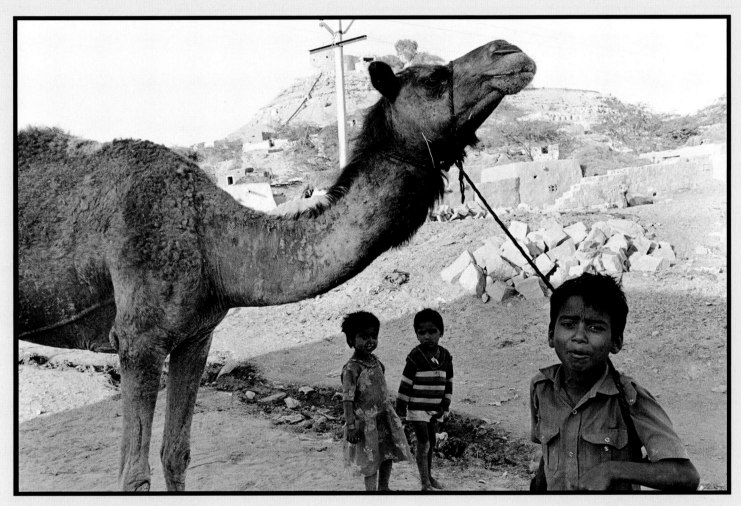

17. Tending family camel, India, 1993

AGRICULTURE
AND HUSBANDRY

Children in coastal areas fish or help farm coastal waters. In Indonesia, up to two thousand fishing platforms, called *jermals,* rise from stilts in the ocean around Java and Sumatra [PLATES 21-23]. Labor contractors lure young workers from inland villages with promises of good wages. Because the platforms lie far out at sea the children cannot escape. Platform workers subsist on rice; fresh fruit and vegetables are a rare luxury and potable water is brought in just once a week. The bosses often subject the children to physical and sexual abuse.

In eastern Morocco, children wander the desert tending sheep and herding camels. Similarly, in India and Nepal, children feed and herd camels and other animals [PLATE 19]. Many of these children work alone all day. Although this may be a traditional way of life for some, these children miss out on the opportunities afforded by even a basic education.

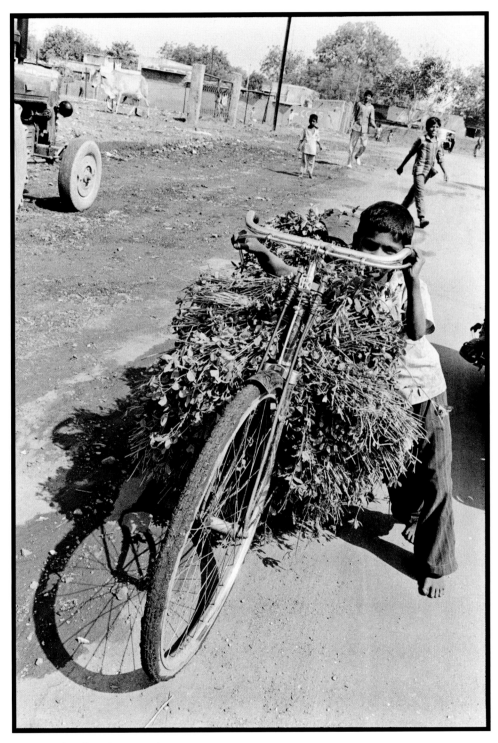

18. Agricultural worker, Nepal, 1993

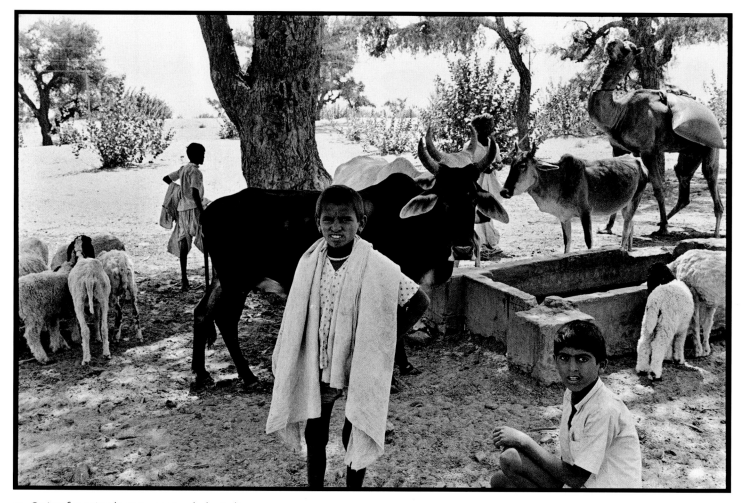

19. Caring for animals at a watering hole, India, 1993

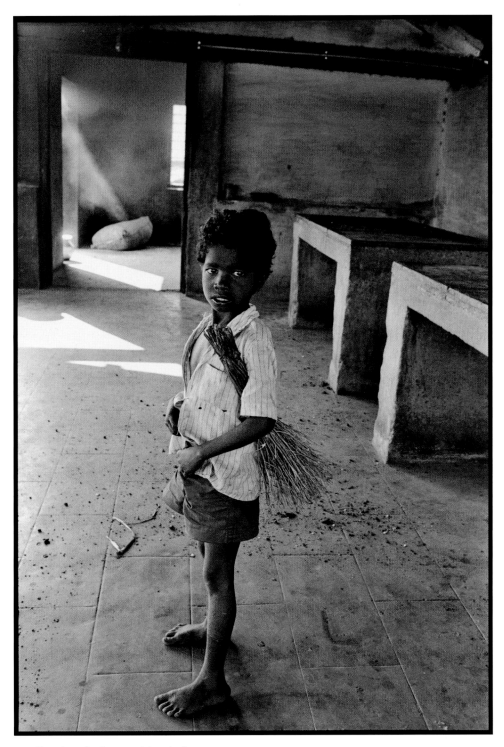

20. Cleaning elephant stables, India, 1995

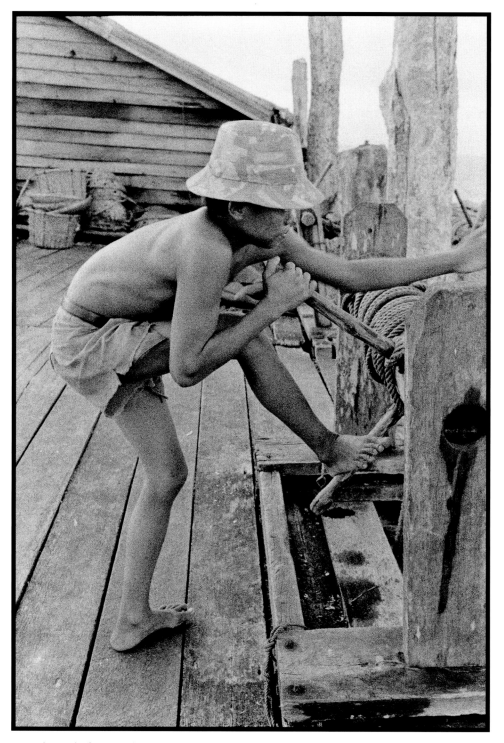

21. Fishing platform worker hoisting a net, Indonesia, 1995

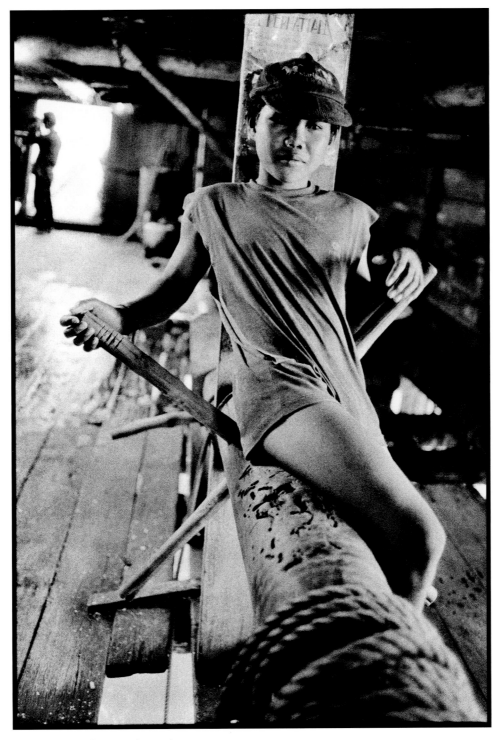

22. Fishing platform worker, Indonesia, 1995

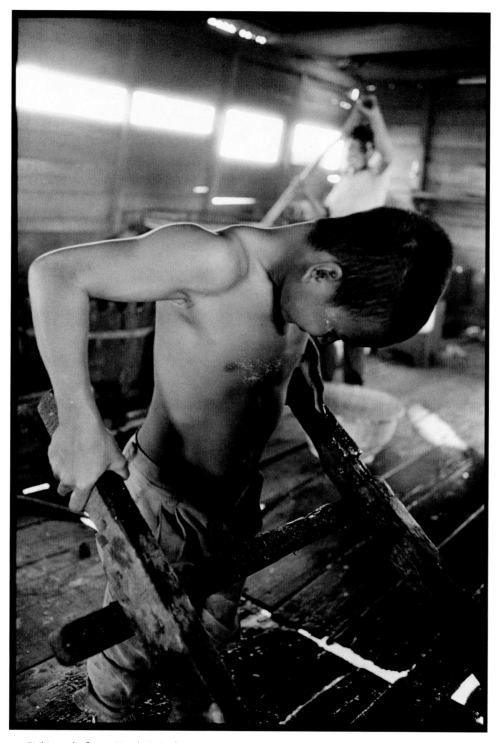

23. Fishing platform (Wealer), Indonesia, 1995

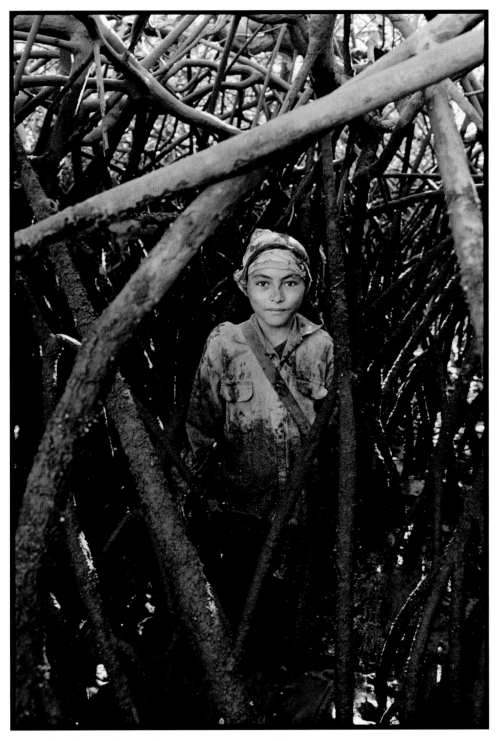

24. Looking for conch shells in a mangrove swamp, Nicaragua, 2004

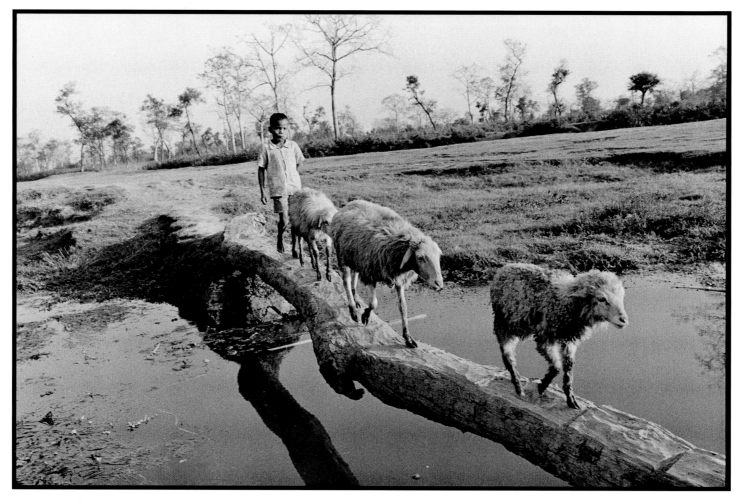

25. Herding sheep, Nepal, 1993

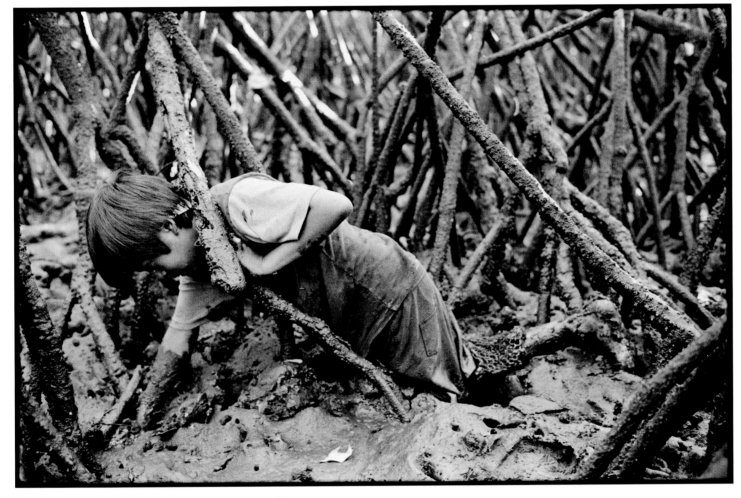

26. Looking for conch shells in a mangrove swamp, Nicaragua, 2004

42

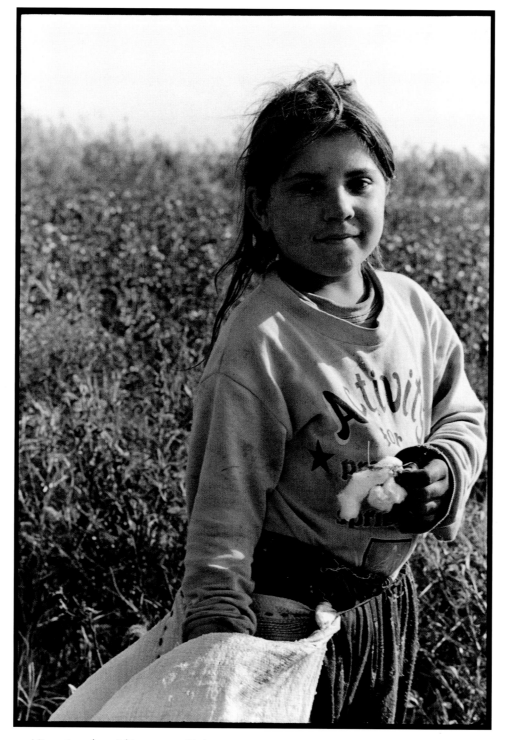

27. Migrant worker picking cotton, Turkey, 1997

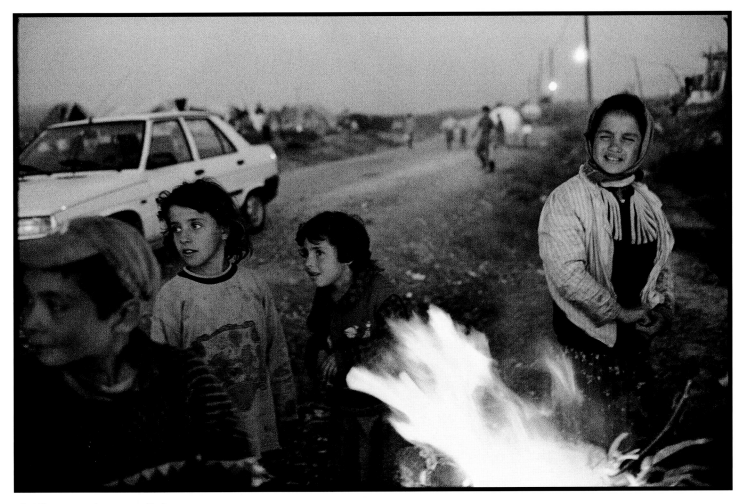

28. Migrant worker camp, Turkey, 1997

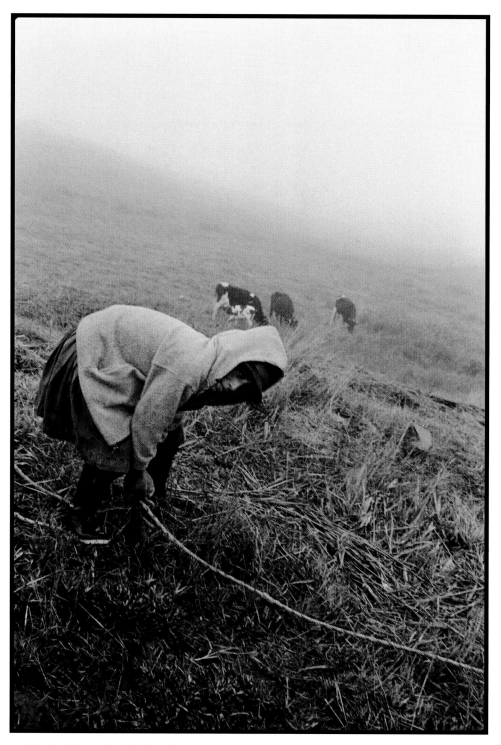

29. Tending farm animals, Ecuador, 2002

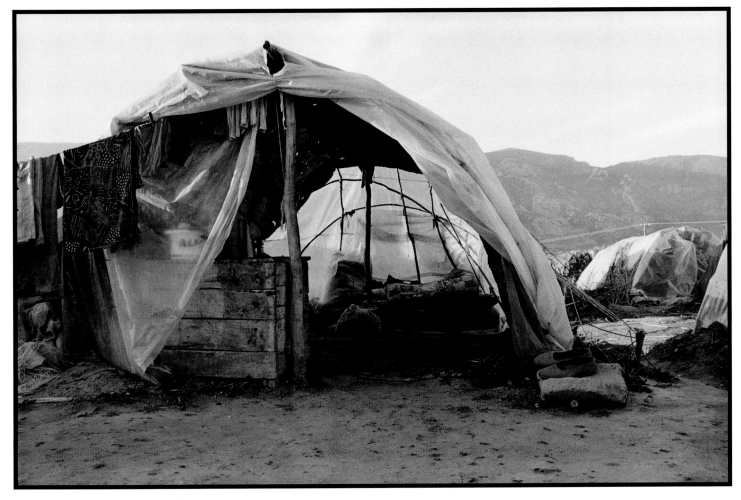

30. Tent for migrant workers, Turkey, 1997

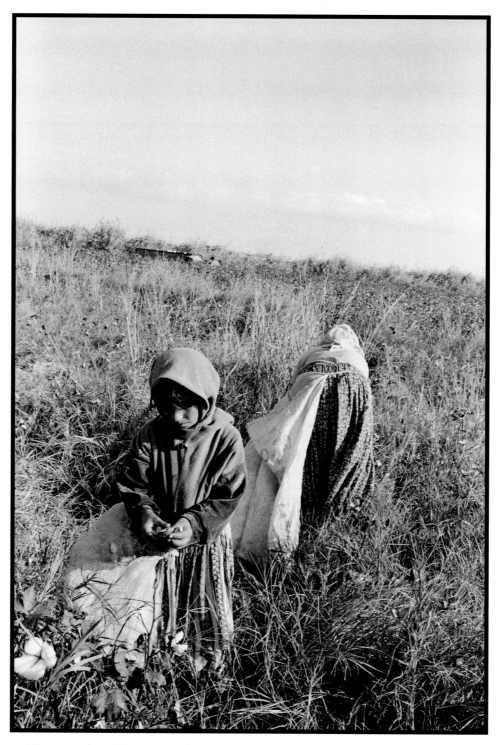

31. Migrant worker picking cotton, Turkey, 1997

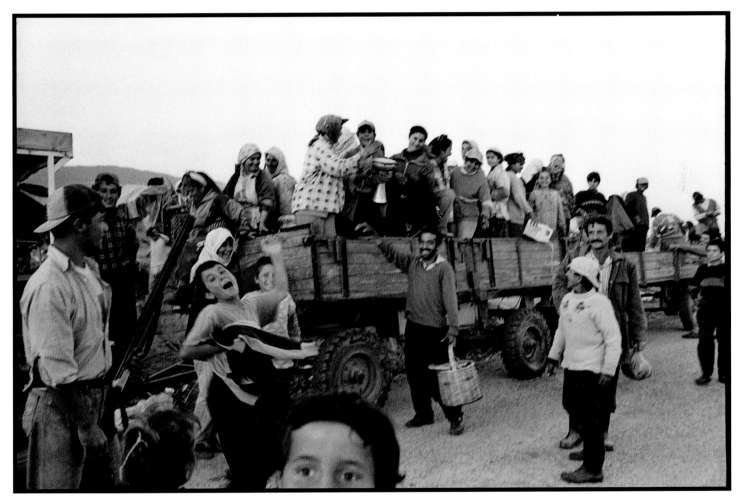

32. Migrant workers returning to their camp, Turkey, 1997

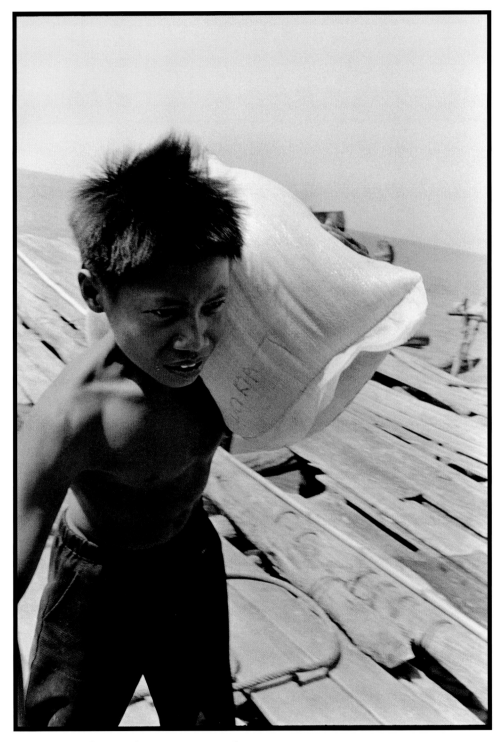

33. Fishing platform worker carrying rice, Indonesia, 1995

FREQUENTLY CITED IN LEGISLATION as forms of hazardous labor, mining and quarry work are two of the most dangerous occupations. Globally, more than one million children mine gold, tin, silver, diamonds, lime and other types of stone. Children blast and cut rock, break stones, haul materials, and dig. Depending on the type of mining or quarrying, they may work underground [PLATE 34] or aboveground [PLATE 36].

Perhaps the best description of young miners' work comes from the International Labour Office, which reports, "In mines, children descend to the bowels of the earth to crawl through narrow, cramped, and poorly lit makeshift tunnels where the air is thick with dust. They constantly risk fatal accidents due to falling rock, explosions, collapse of mine walls, and the use of equipment designed for adults."[6]

Stone quarrying is the most common type of mining work done by children. Workers crush stones to form aggregate that is used in construction. Families sit on the roadside and break apart stones that have been delivered by truck. Young children use small hammers; the hammers get larger as the children grow [PLATES 40–41]. Flying chips of stone can lodge in workers' eyes.

Child miners inhale large amounts of dust, particularly when they work near giant machines that mechanically crush stone. After being crushed the stones move along a conveyor, where smaller pieces are sorted by size. After this sorting, workers carry the stones in baskets or buckets to sell or store them. The machine process offers no control over the amount of dust that workers breathe in [PLATES 46–47]. Dust from coal, asbestos, and silica can cause lung diseases. Although varieties of dust cause different types of disease, they all gradually deprive a person of air.

In some parts of the world, young gold miners grind stone into a fine powder and extract the gold using mercury. The crushed, gold-containing ore is

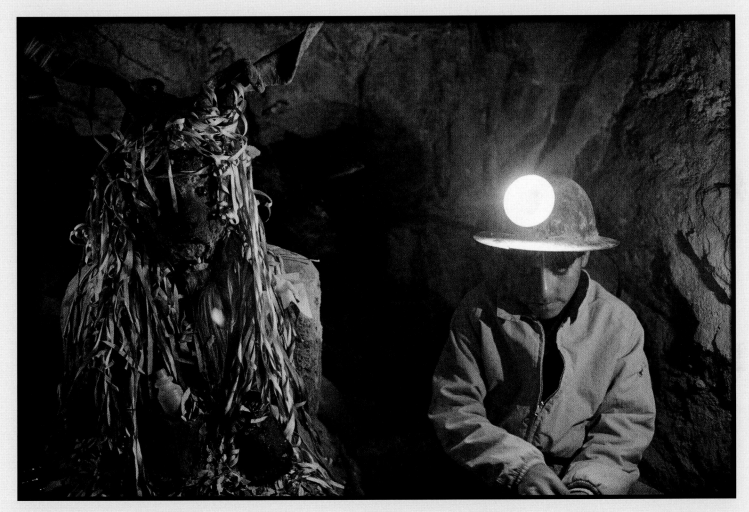

34. Tin miner and Tio, Bolivia, 1998

MINES AND STONE QUARRIES

mixed with mercury to form a solution (amalgam) in which the gold dissolves [PLATE 39]. Then the amalgam is heated to vaporize the mercury, allowing the gold to be extracted. The evaporated mercury pollutes surrounding villages and water. Mining effluent contaminates rivers and lakes for decades.

Using slave labor, Spanish colonists mined several billion ounces of silver from Cerro Rico (Rich Mountain) in Potosí, Bolivia. In 1572 the Spanish viceroy ordered that all males between the ages of eighteen and fifty labor for four months in the mines every seven years. An estimated 80 percent of the male population of Quechua Indians died in the mines in the late 1500s.[7]

Today forty to fifty cooperatives and independent workers operate what is left of these colonial mines. Workers have limited access to modern technology. The mines tunnel deep into the earth, where workers toil in unfathomably dark, hot, humid conditions. The only light comes from gas lamps on the miners' helmets. The workers carry sacks of dirt and rocks on their backs to the mine openings. There the stones are crushed and the ore extracted.

Pumice miners in Peru are known as *niños topos* (burrowing rats) because they bore holes in the sides of volcanic hills to extract the stone [PLATE 38]. The children in these photographs used to be part of a much larger group that mined pumice in Arequipa, Peru, before the mines closed in the late 1990s.

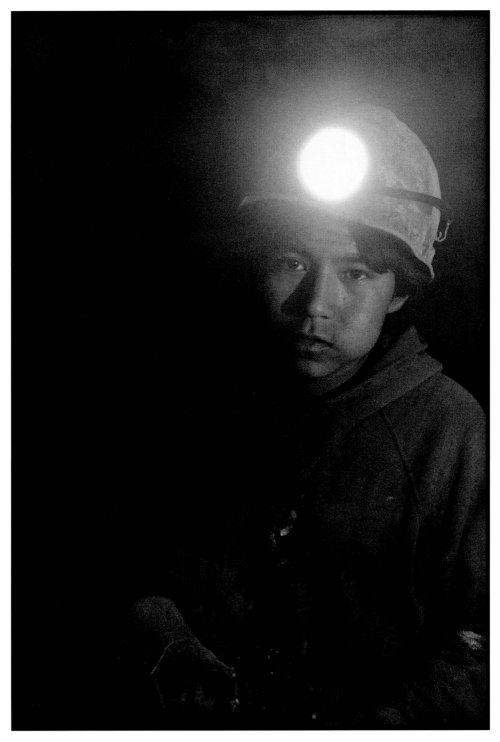

35. Tin miner, Bolivia, 1998

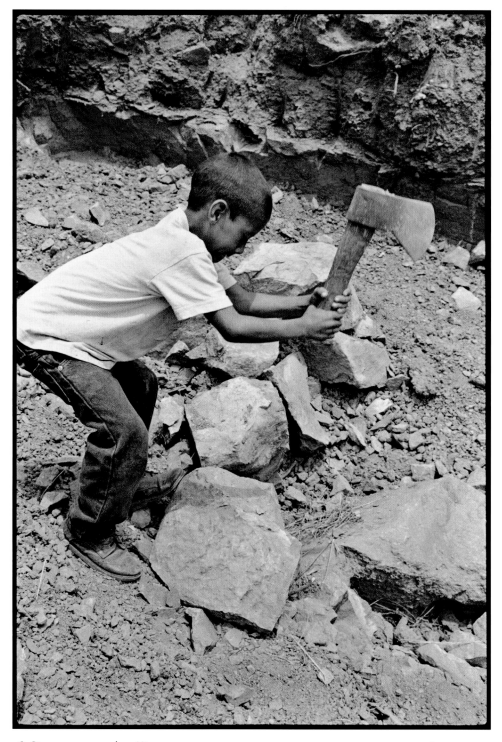

36. Stone quarry worker, Nicaragua, 2004

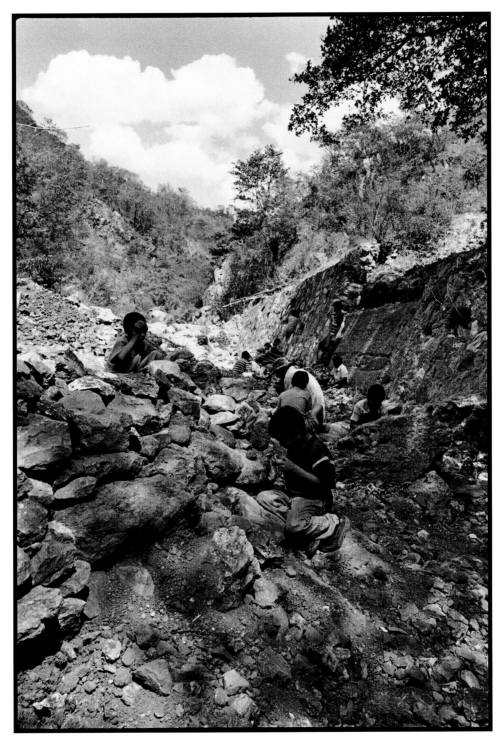

37. Gold miners looking for gold nuggets, Nicaragua, 2004

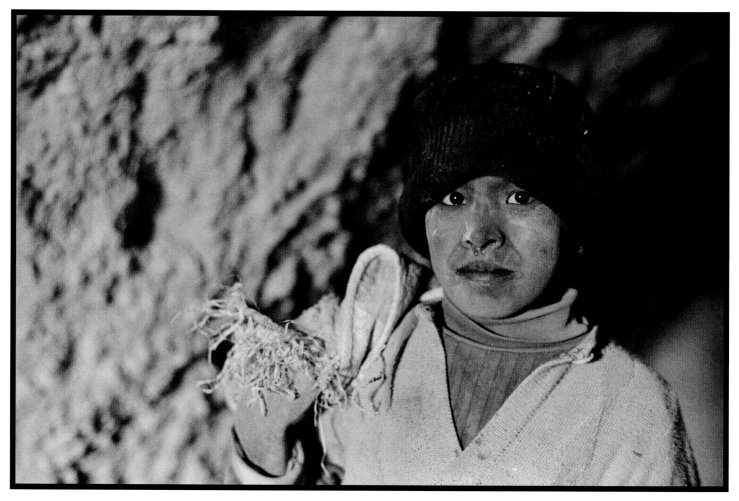

56

38. Pumice miner, Bolivia, 1998

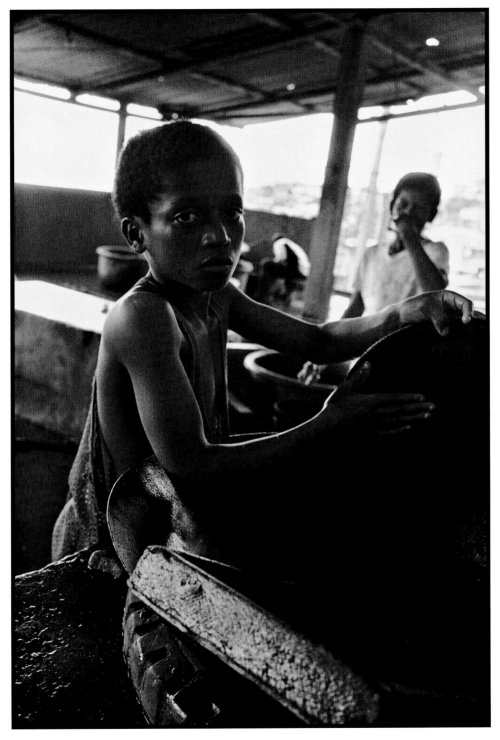

39. Extracting gold with mercury, Ecuador, 2002

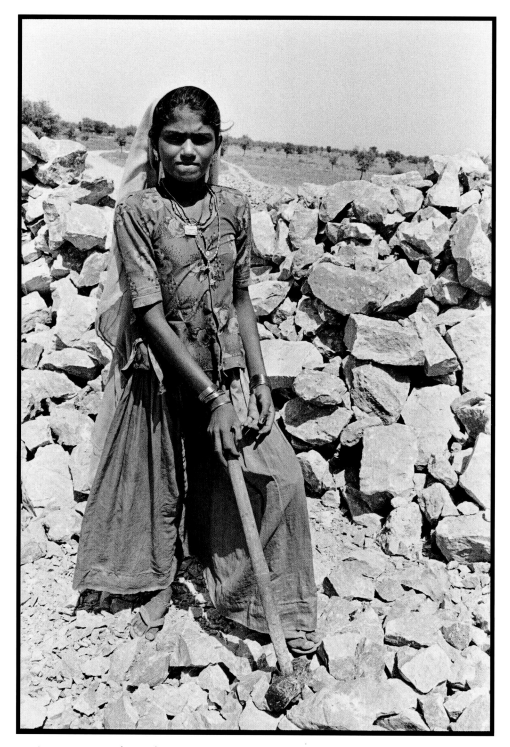

40. Stone quarry worker, India, 1993

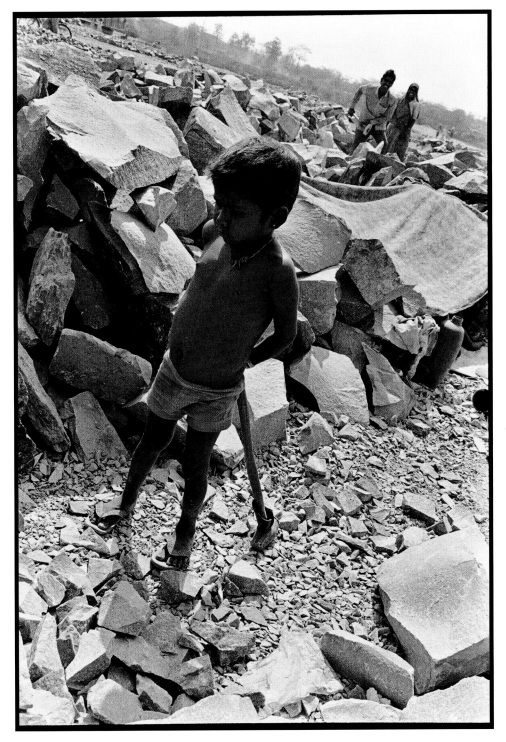

41. Stone quarry worker, India, 1993

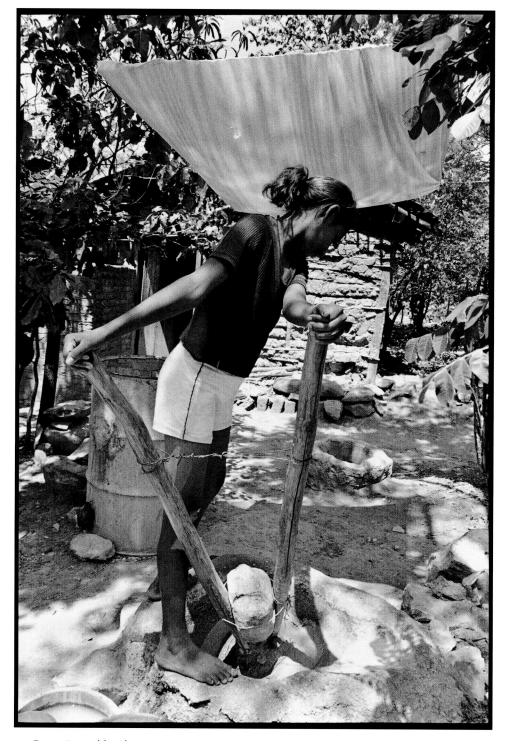

42. Extracting gold with mercury, Nicaragua, 2004

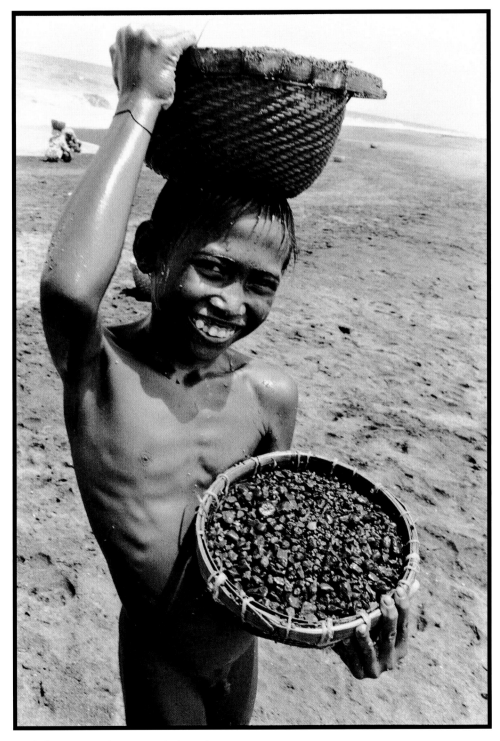

43. Collecting pumice stones, Indonesia, 1995

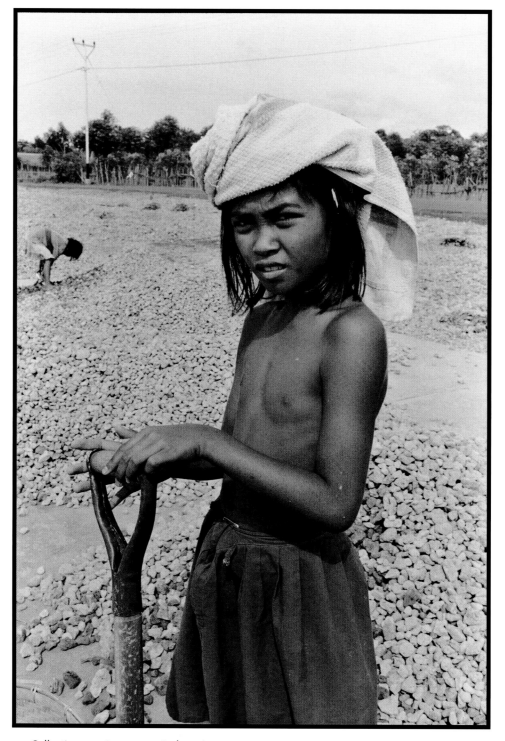

44. Collecting pumice stones, Indonesia, 1995

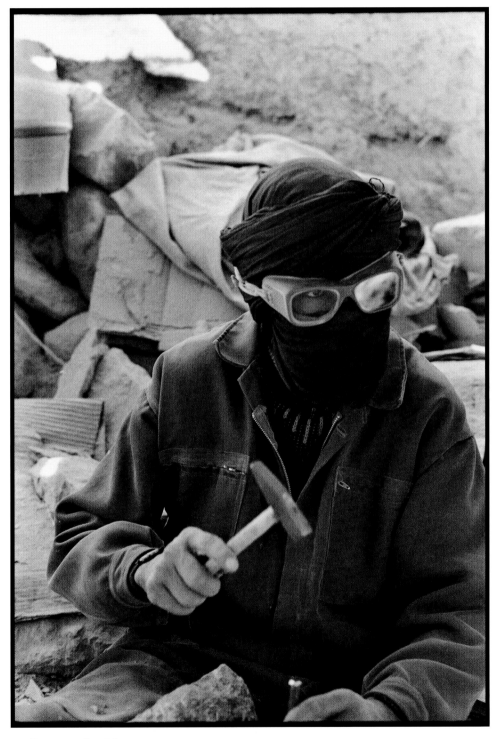

45. Quarry worker, Morocco, 1997

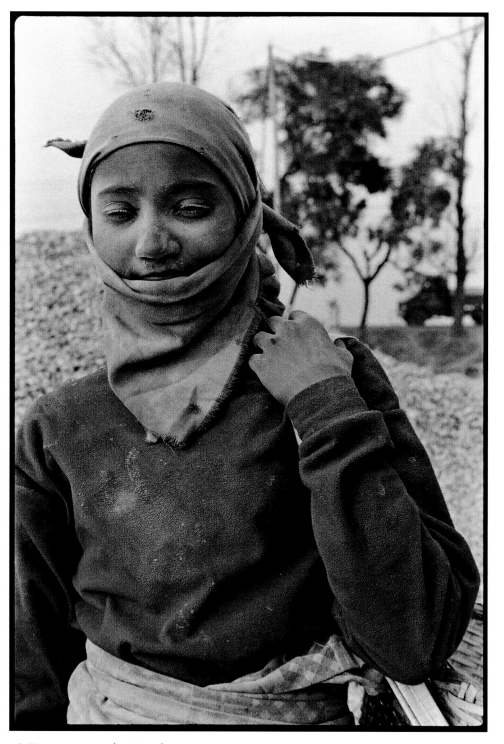

46. Stone quarry worker, Nepal, 2005

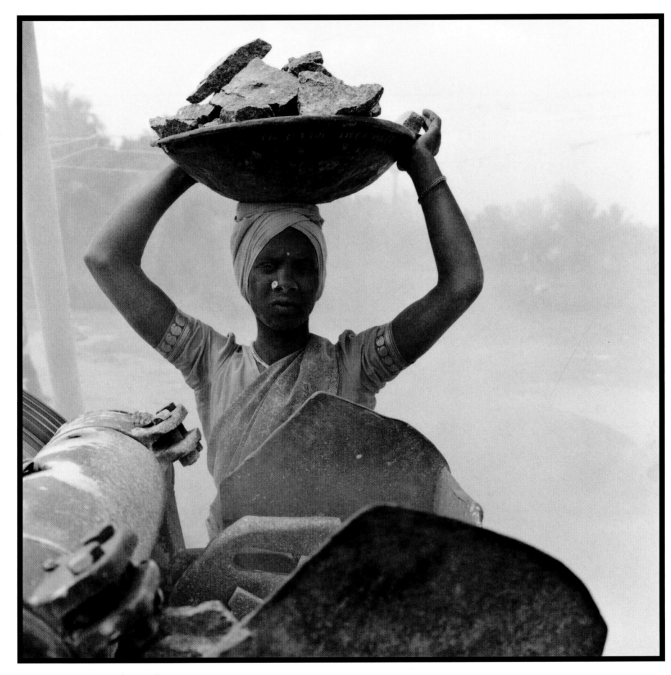

47. Stone quarry worker, India, 1995

THROUGHOUT MUCH OF THE WORLD, bricks are made by hand. In Asia, Latin America, and Africa, children and adults dig clay for bricks using shovels, picks, and awls. During the rainy season, the holes become breeding areas for mosquitoes and other insects. The workers add water and stomp on the clay until it reaches the right texture [PLATE 49]. In Bangladesh, oxen walk in a circle to mix the clay for bricks.

After mixing the clay and water to the proper consistency, workers form bricks using small wooden molds [PLATE 51]. Children sprinkle sand into the mold and on the clay to prevent sticking. Then they scoop up the clay by hand and throw it into the mold [PLATE 52]. Using a sharp wire they trim extra clay off the top of the wet brick. In some regions, the mold is turned upside down to release the brick; in others, the mold has no bottom. Finally, the bricks are stamped with the manufacturer's name and laid in the sun to dry.

When the bricks are dry, barefoot workers load them on their backs or on top of their heads and carry them across fields of stones and broken bricks [PLATE 55]. The workers stack the bricks in kilns, where they are covered with dirt and fired. Fuel may be wood, coal, used plastic items, or old car tires [PLATE 56]. As workers remove bricks from the kiln, the bricks sometimes fall on their bare feet. The fired bricks are dry and dusty. Workers breathe in the dust and get it in their eyes as they carry the finished bricks and stack them for shipping or storage.

A small brick factory may produce more than half a million bricks a year. Each brick weighs two to four kilograms (4.4 to 8.8 pounds). A small child may haul one thousand to two thousand bricks each day [PLATE 50].

Anti-Slavery International, an organization working to eliminate slave and bonded labor, describes the treacherous conditions in the brickyards: "All over India in the outskirts of urban areas there are brick kilns. A million children under guard work at these (brick factories) in families with their parents, broth-

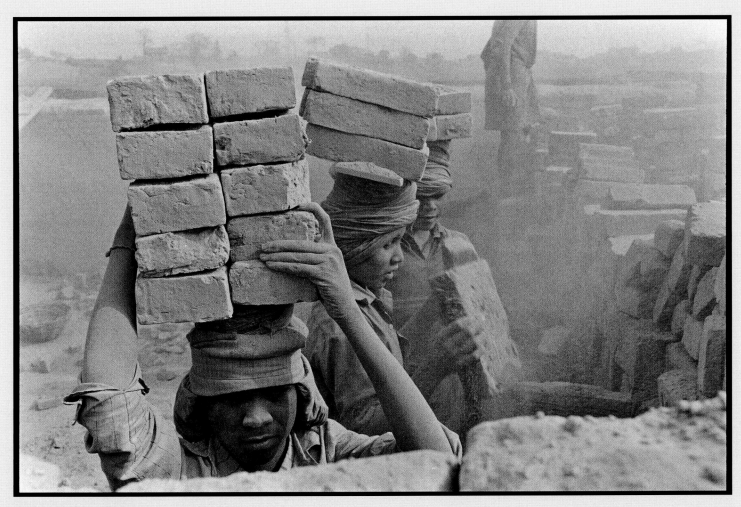

48. Hauling bricks out of a kiln, Nepal, 1993

BRICK WORKERS

ers, and sisters; these illiterate, landless families belong to scheduled castes and tribes…similarly in many places there are stone quarries and, for the same reasons, poor, illiterate landless families work to pay off debts incurred through unemployment, poverty, drought and disaster. They dig the stone out of the earth with bare hands and makeshift tools, cart heavy loads on their heads, remove debris, and break stones."[8]

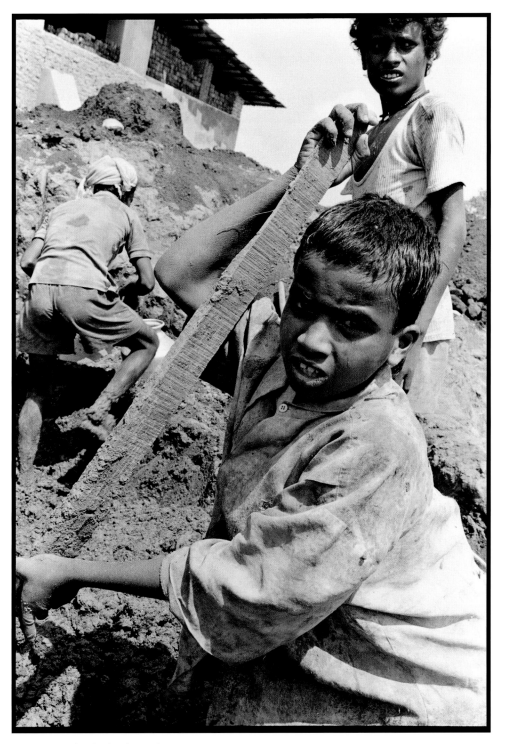

49. Mixing clay for bricks, India, 1995

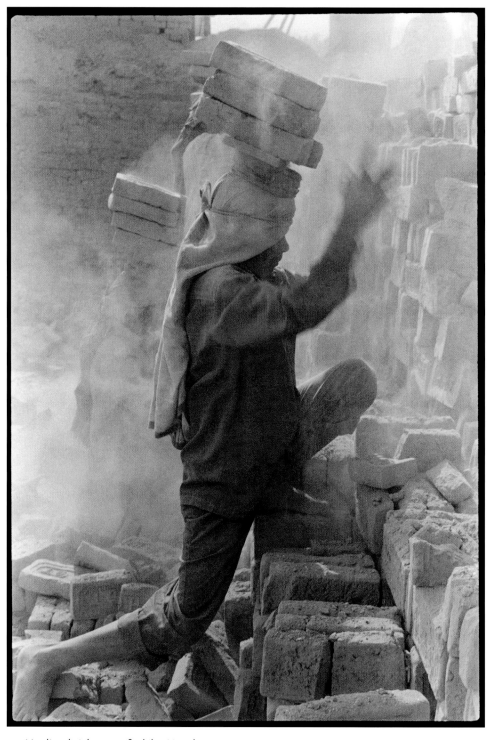

50. Hauling bricks out of a kiln, Nepal, 2002

70

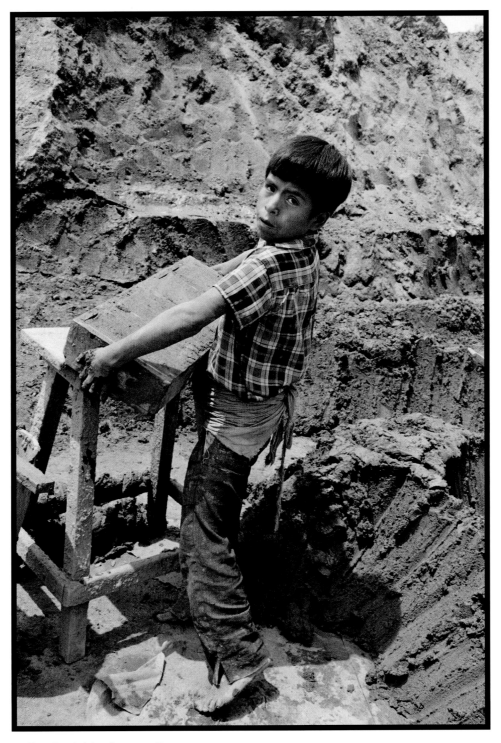

51. Forming bricks, Peru, 1998

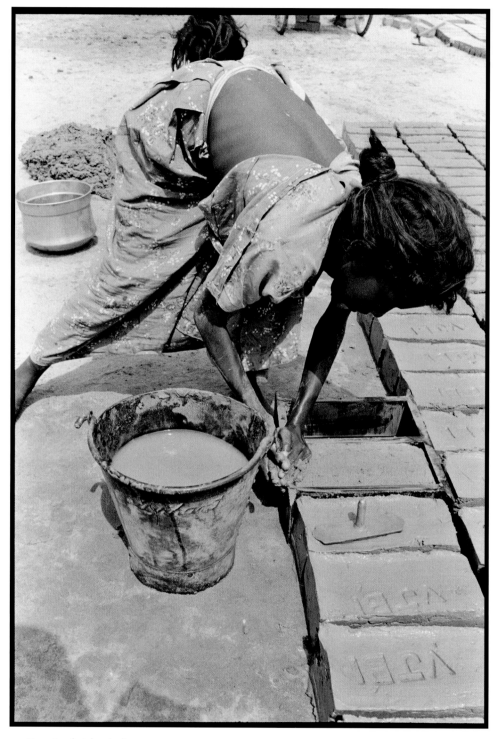

52. Forming bricks, India, 1995

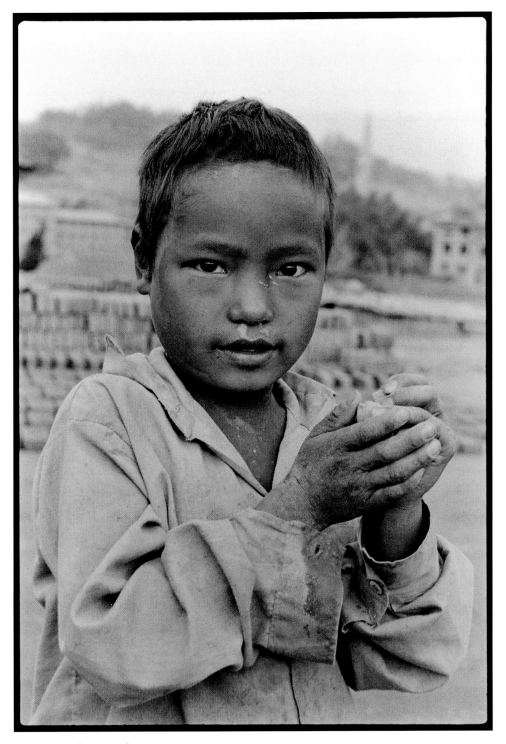

53. Brick worker, Nepal, 2002

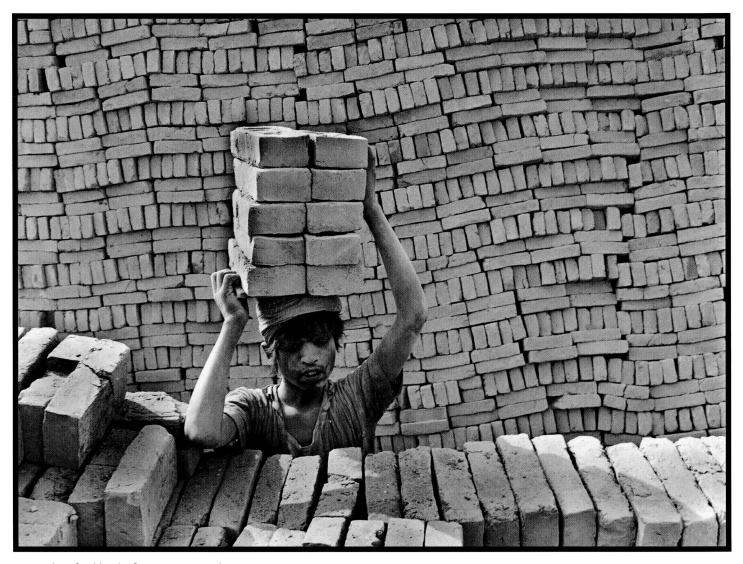

54. Hauling fired bricks for storage, Nepal, 1993

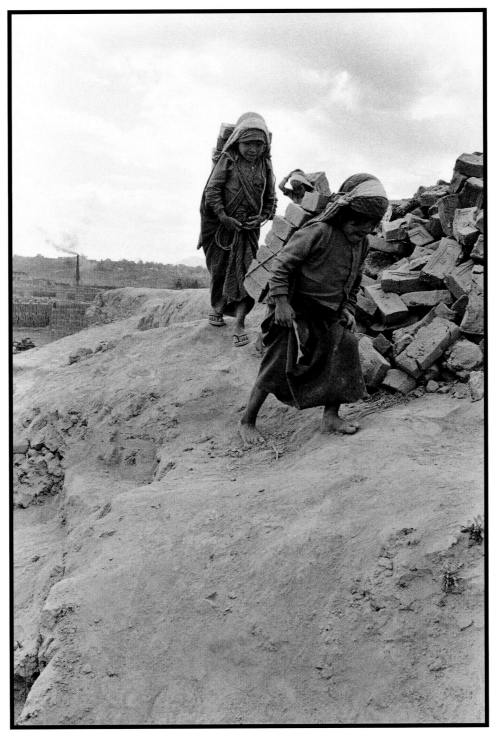

55. Hauling bricks for firing, Nepal, 1995

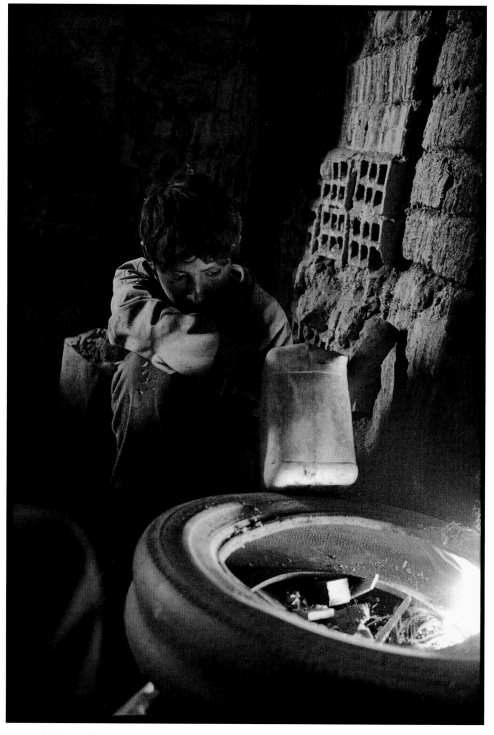

56. Brick kiln, Bolivia, 1998

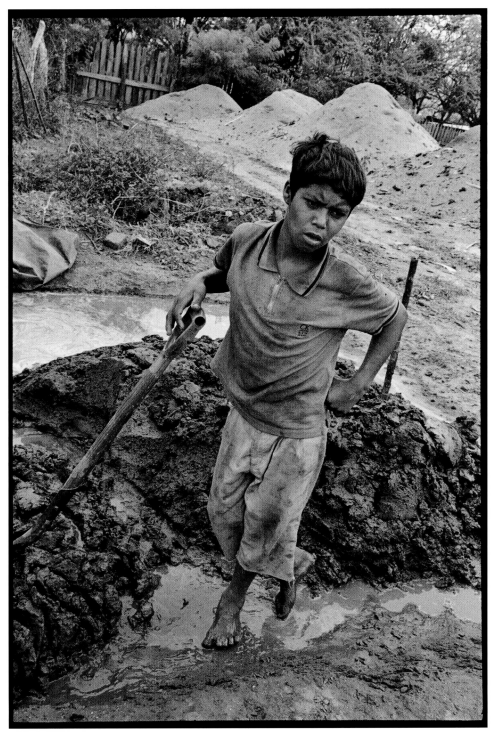

57. Mixing clay for bricks, Nicaragua, 2004

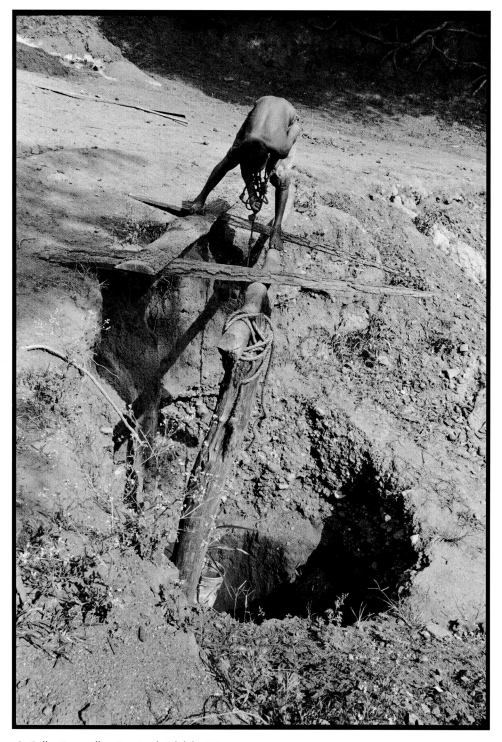

58. Collecting well water at a brick kiln, Nicaragua, 2004

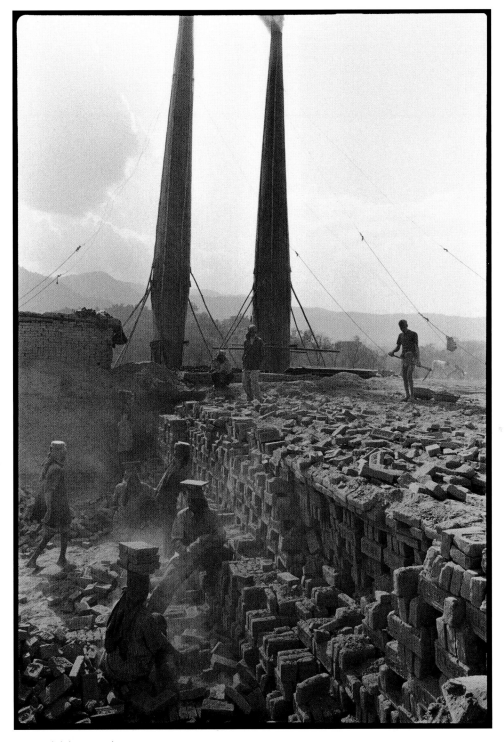

59. Brick kiln, Nepal, 2002

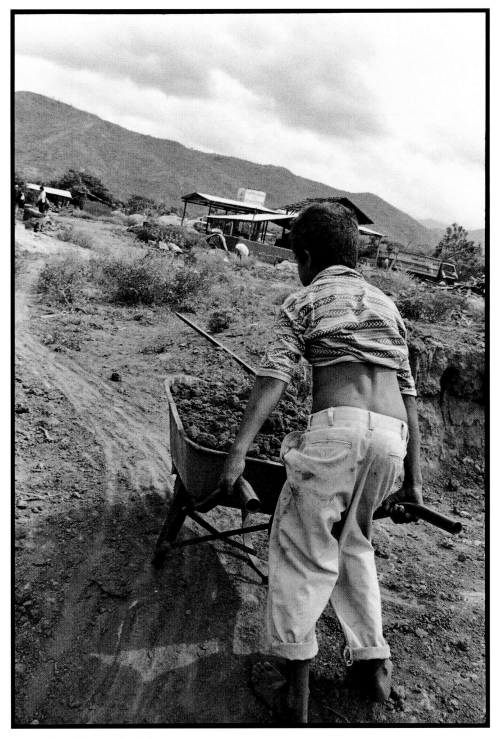

60. Hauling clay at a brick factory, Nicaragua, 2004

MOST CHILDREN EMPLOYED IN MANUFACTURING WORK in small shops that rely on manual labor. Children spin wool or silk, sew clothing, weave carpets, make decorative crafts, tan leather, fabricate metal products, and mix explosives for fireworks. Because manufacturing involves such a diverse range of activities, the dangers child laborers face also vary greatly.[9]

Children working in factories put in long hours with little or no pay. I have read reports about children working ten or more hours every day. When I toured carpet factories in India and Nepal, children were working at the looms in the early morning when I arrived and were still there when I returned in the late evening. Almost all children in manufacturing must contend with inferior working conditions, including noise, dust, and dangerous high-speed equipment.

One of the best-described industries is textile manufacturing, including garments and hand-knotted carpets. More than any other industry, textiles have come under scrutiny for the use of child labor and worker exploitation. Media exposés have targeted major clothing retailers and the carpet industry. Missing from most reports are stories about children who tan leather, pick cotton, spin wool or silk, weave cloth, and sew native decorative crafts of cotton or wool.

In India, Nepal, Pakistan, Turkey, and other nations, children knot wool or silk carpets. Four or five square centimeters of carpet may have 100 to 200 hand-made knots. One square meter includes 130,000 to nearly 260,000 knots. Children who spend day after day doing this type of detailed handwork are likely to develop arthritis at an early age. Virtually all children who knot carpets get skin rashes and frequently cut their hands with razors or knives. The factories are dark and poorly ventilated and children work for long hours squatting in front of a loom.[10]

Children also tan leather in cottage industries around the world. Leather tanning is one of the dirtiest jobs imaginable, carried out in a tumbling barrel or large vats using chromic acid, oxalic acid, formaldehyde, and alkalis such as

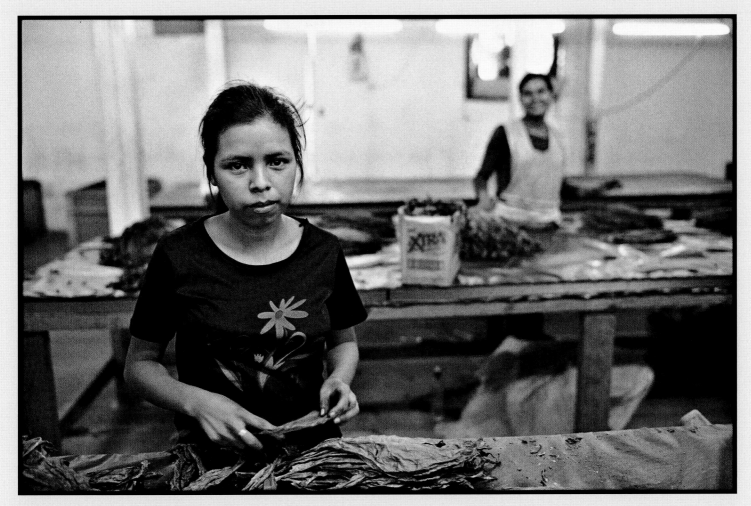

61. Sorting cigar tobacco, Nicaragua, 2004

TEXTILES AND OTHER
MANUFACTURING

trisodium phosphate and borax. In addition to exposing workers to toxic chemicals, the process releases carbon monoxide, hydrogen sulfide, and other noxious gases. Children are exposed to putrefied animal waste as well. In spite of these hazards, children work in tanning fluids or climb into large tanning drums to remove partially tanned hides [PLATE 66].

In other factories, high-speed grinders cut and polish drinking cups, dinner plates, and small metal objects. Spinning at rates of six hundred to a thousand revolutions per second, a grinder can amputate a finger or hand in a fraction of a second. The machines are difficult to operate safely even by a skilled adult. It's even more dangerous for a small child who is barely able to reach the machine [PLATE 63]. Children also weld parts [PLATE 64] or bend steel to make ornamental iron [PLATE 62].

In India, Guatemala, and other places, children make fireworks and matches. Children take part in all steps of the manufacturing process, including mixing gunpowder or potassium nitrate and cutting firecracker tubes with machetes. In Sivakasi, India, fifty thousand to seventy thousand children produce matches and pyrotechnics. Workers board buses before sunrise to make the two-hour trip to the factories and do not arrive back home until late evening. In Guatemala, small factories are attached to homes. These families face the risk of an explosion that can destroy their home and injure family members [PLATE 73].

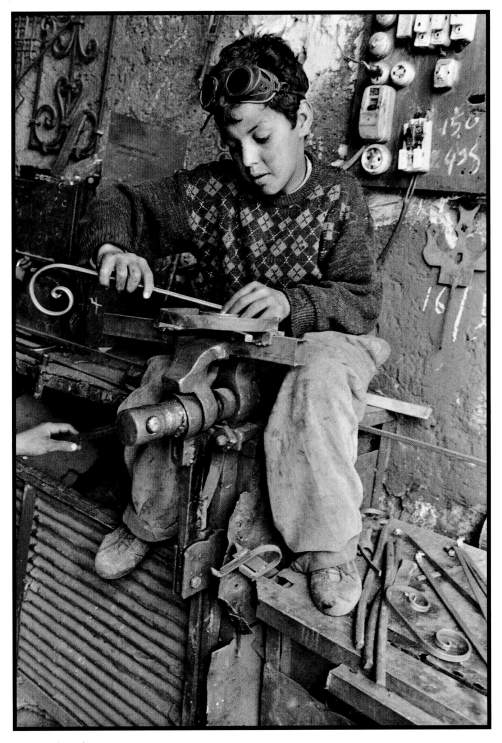

62. Metal worker, Morocco, 1997

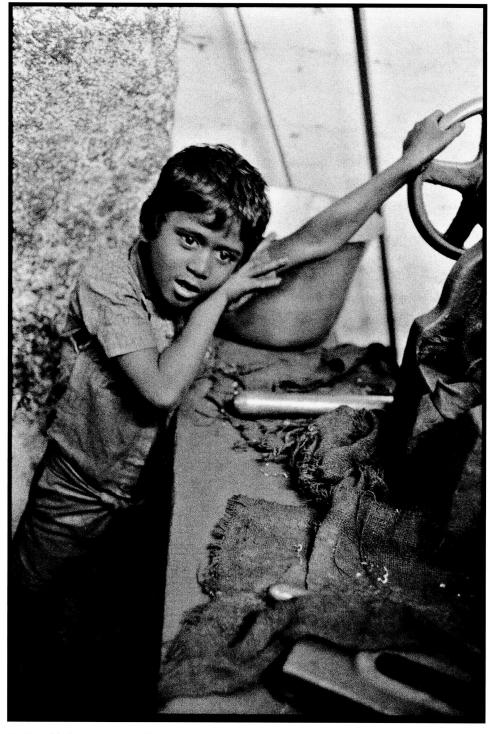

63. Metal lathe operator, India, 1995

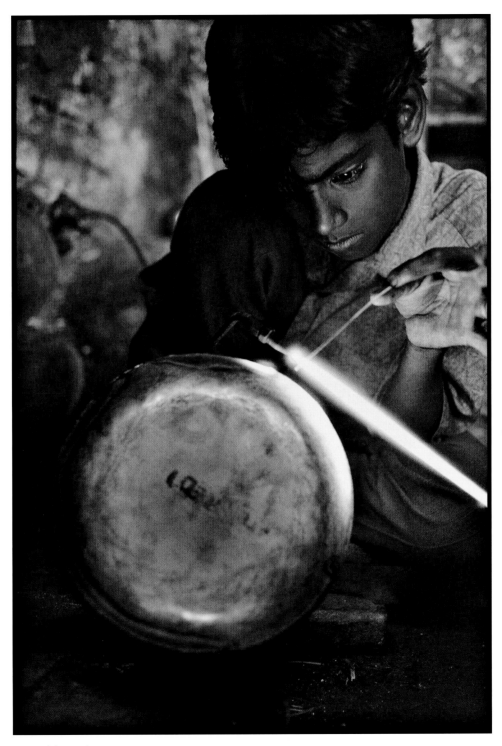

64. Welder, India, 1995

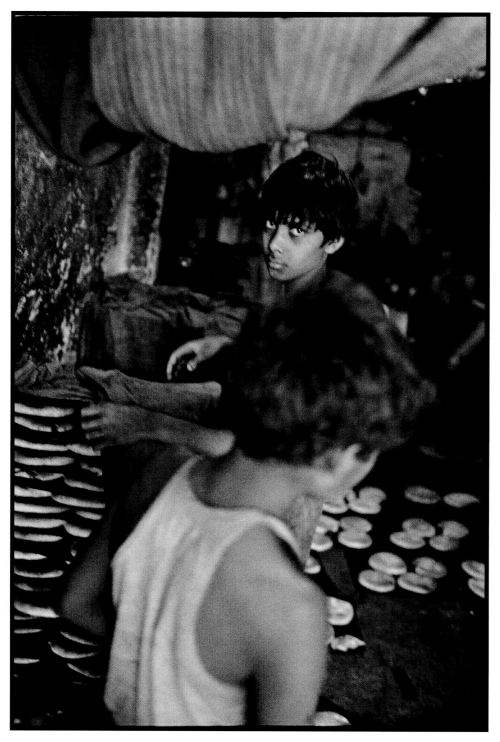

65. Bakery, India, 1993

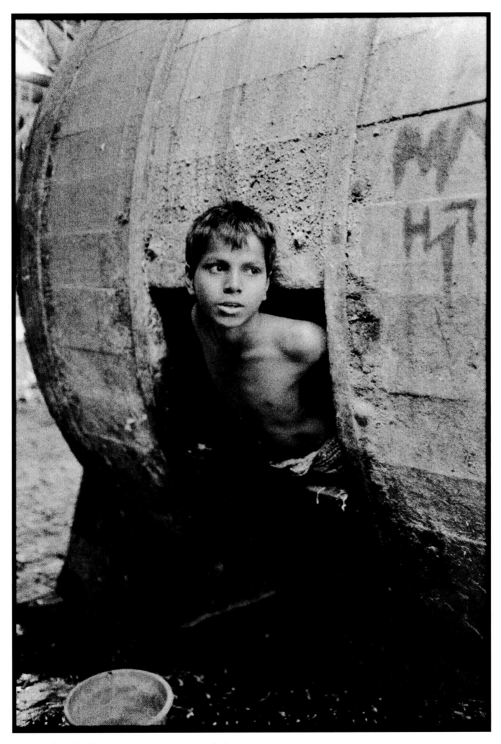

66. Inside a leather tanning drum, Bangladesh, 1993

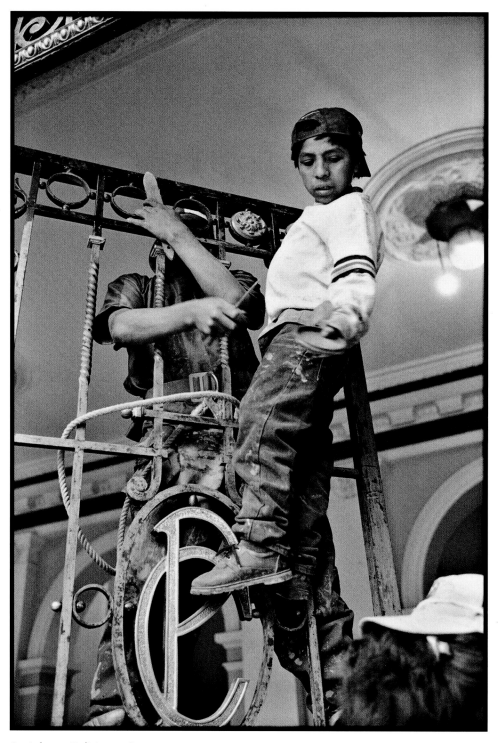

67. Laborer, Bolivia, 1998

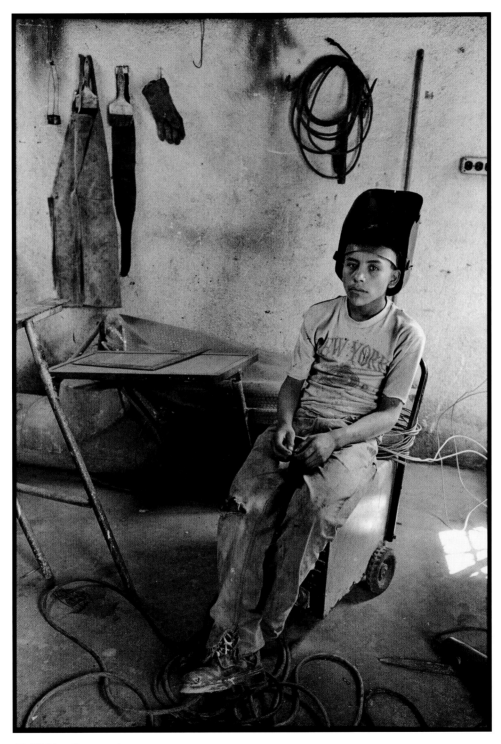

68. Welder, Guatemala, 2000

92

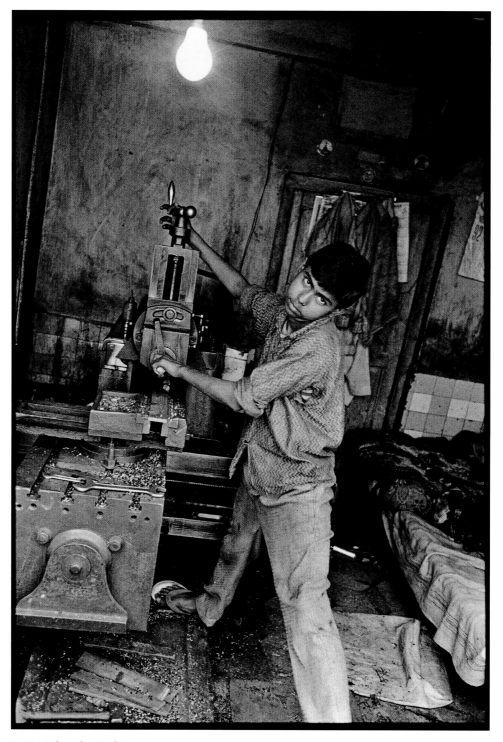

69. Metal worker, India, 1993

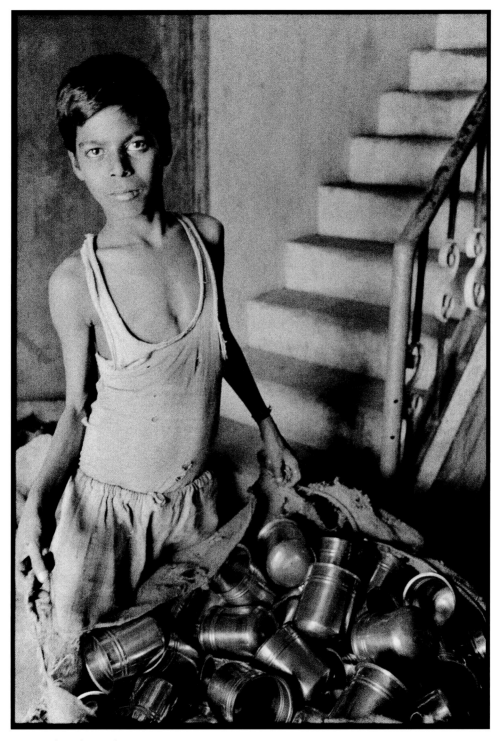

70. Metal worker, India, 1995

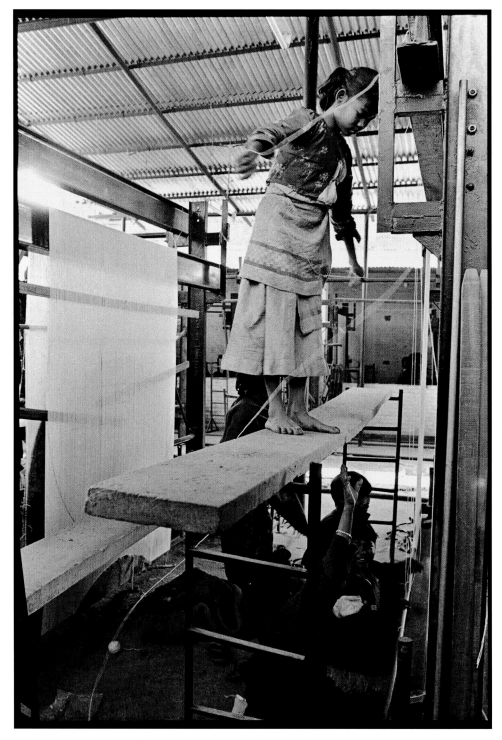

71. Carpet weavers, Nepal, 1993

94

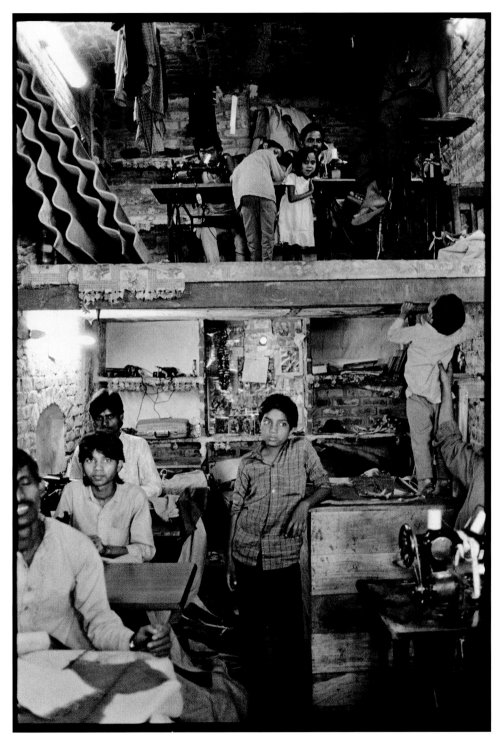

72. Textile factory, India, 1993

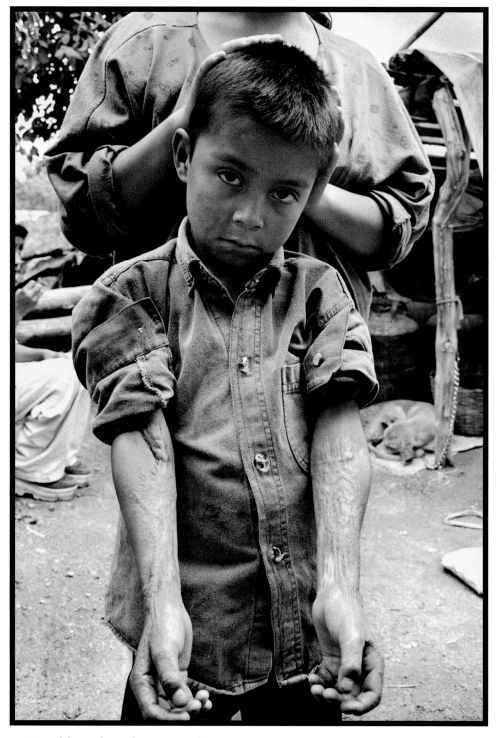

73. Injured fireworks worker, Guatemala, 1999

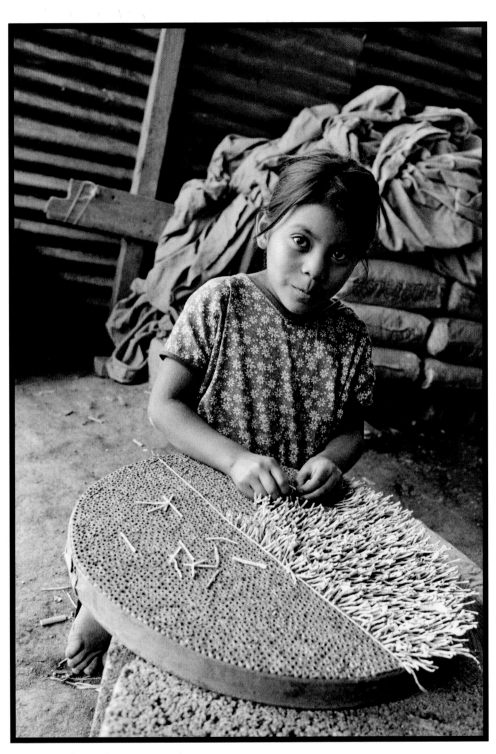

74. Making firecrackers, Guatemala, 1999

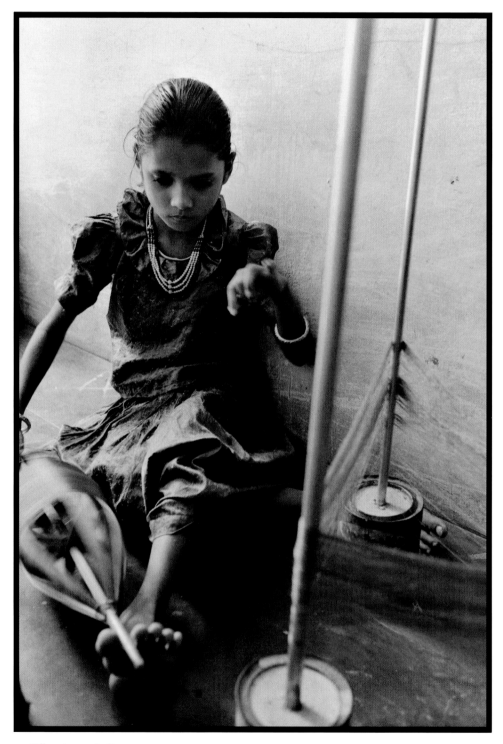

75. Silk spinner, India, 1995

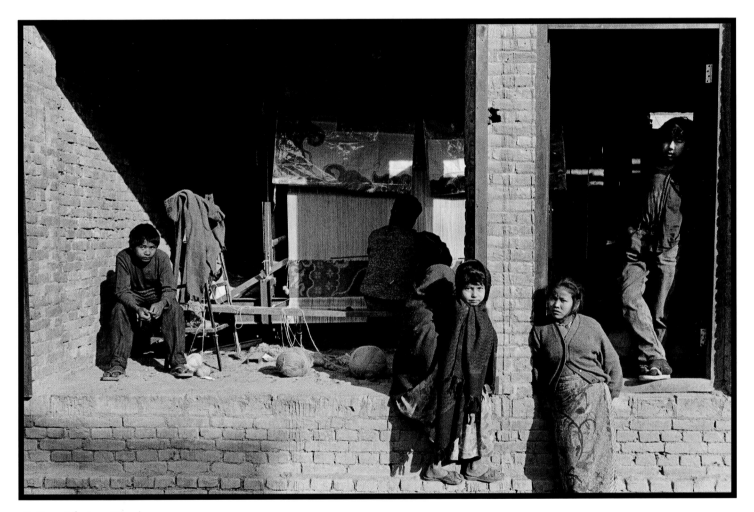

76. Carpet factory, Nepal 1993

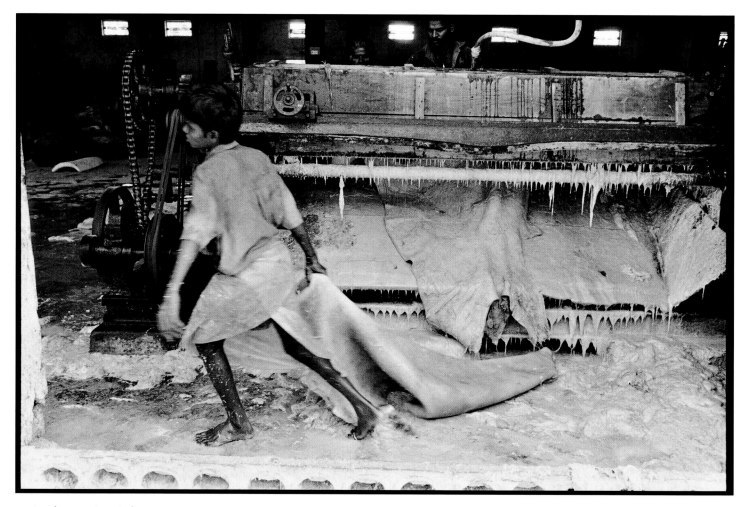

77. Leather tanning, India, 1995

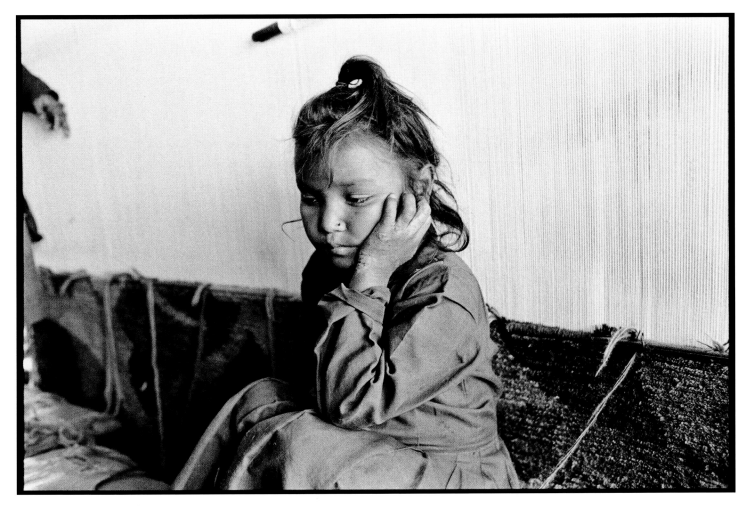

78. Carpet weaver, Nepal, 1993

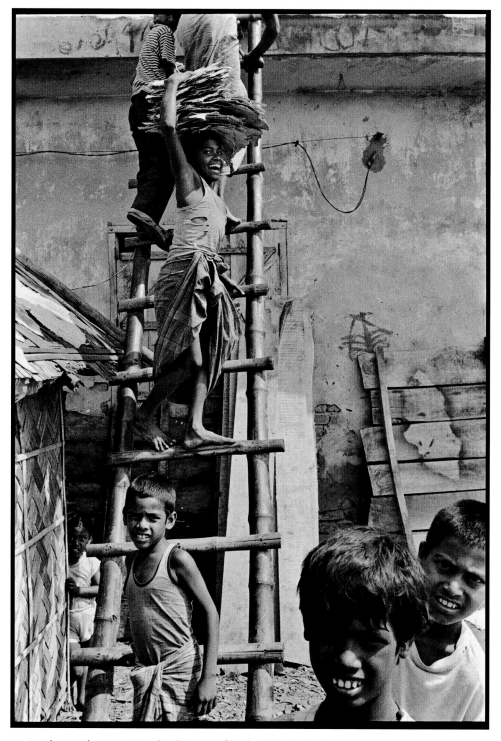

79. Leather workers carrying dried pieces of leather, Bangladesh, 1993

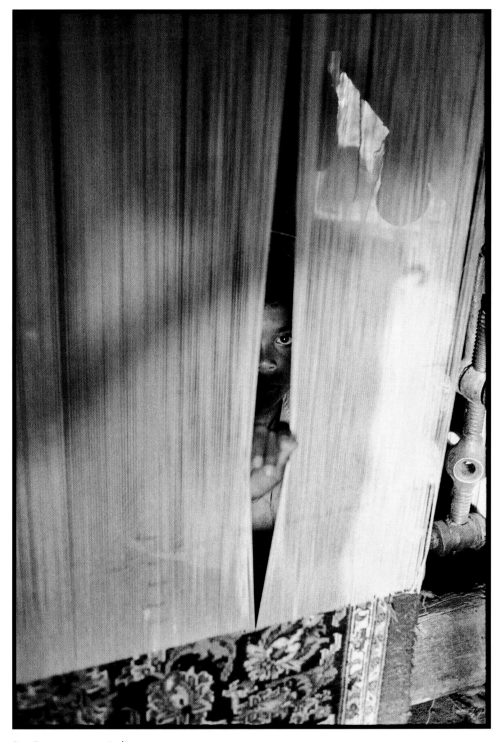

80. Carpet weaver, India, 1993

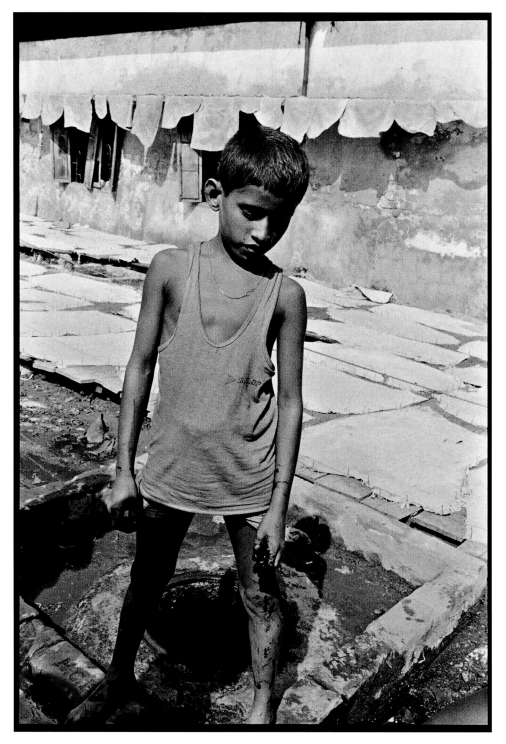

81. Leather tannery, Bangladesh, 1993

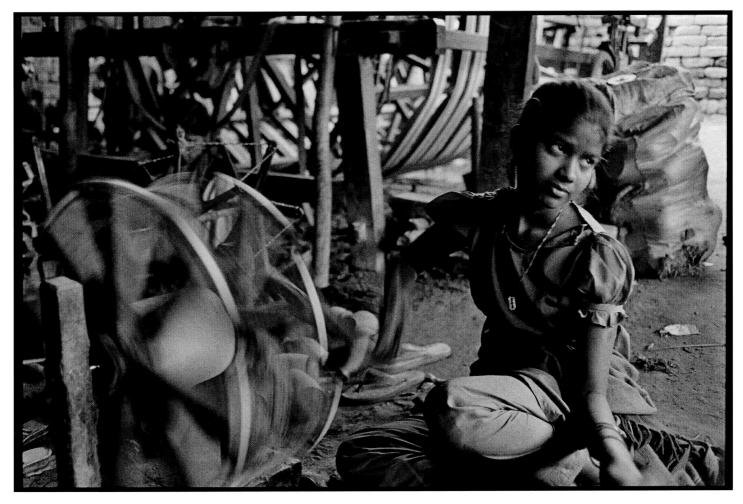

82. Spinning wool, India, 1993

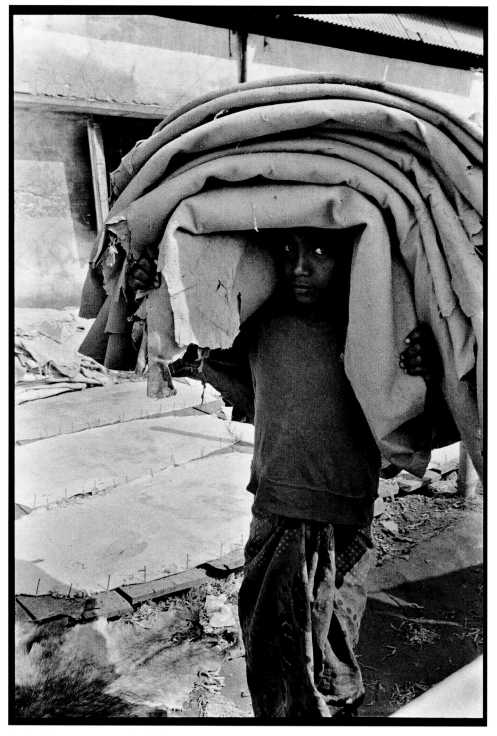

83. Leather tannery, Bangladesh, 1993

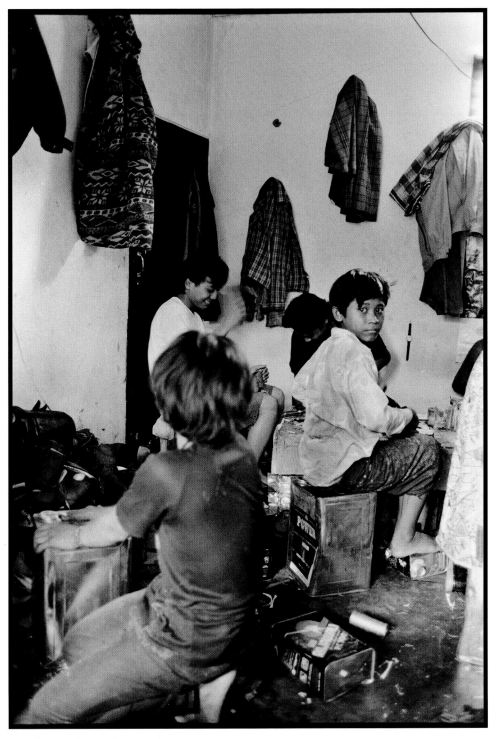

84. Gluing soles to shoes, Indonesia, 1995

AS MANY AS 100 MILLION CHILDREN work on the streets, and 40 million of them may be homeless, according to the United Nations Children's Fund (UNICEF).[11] In countries where child labor is prevalent, street jobs and begging are a catchall for children who cannot or do not wish to find other types of work.[12] In large cities, street workers frequently make up the greatest number of child workers.[13]

Laws that restrict child labor in the formal sector may inadvertently shift children from the factory to the street. Shoe shining, selling food or newspapers, running odd jobs, entertaining, directing traffic at intersections, and engaging in prostitution are common street jobs.[14]

Though street work offers some children autonomy from adult oversight, it also subjects them to abuse by other children and adults. I recently conducted a series of workshops in Nicaragua in which we trained government and social workers in ways to identify hazardous child labor. Community workers expressed the concern that children who work on the street are raped, robbed, or cheated of their earnings.

Regardless of reason or country, once on the street these children work or beg to support themselves and their families. Many children have been purposefully disfigured to gain sympathy and consequently more money. On the streets, children also fall prey to drugs, sexual and physical violence, and prostitution.

Globally, an estimated 1.8 million children are engaged in prostitution and pornography [PLATE 109–111].[15] A taxi ride in Bangkok or a late-evening stroll through the central part of the city, known as Patpong, reveals the easy sale of young boys and girls. Young women sit in front of brothels drinking alcohol and waiting for the next customer [PLATE 12].

Around the world, children work in virtually all aspects of the tourist industry. Indeed, youth and beauty are among the few qualifications for employment. In

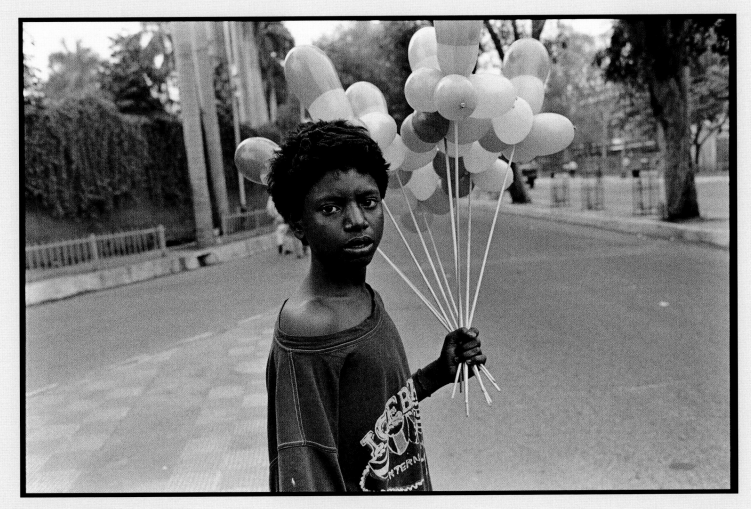

85. Balloon vendor, India, 1993

STREET WORKERS

a largely anonymous atmosphere, Western tourists spend money freely and often cross the line between propriety and blatant sexual exploitation. This has been described as a twilight zone.[16]

In recent years, the trafficking of children has become a problem of global proportions. Increasingly, children are bought and sold across international borders by organized networks. According to a 2005 UNICEF report, approximately 1.2 million children are trafficked each year, and many of them are forced into prostitution. They are kept working under the threat or use of punishment, including starvation, beatings, or an increase in the number of clients they must serve. The rise of AIDS has led sex traffickers to exploit younger children, who are presumably less likely to have AIDS or another sexually transmitted disease.

Children who work or beg on the street often do not keep much of the money they earn. They may turn it over to parents, relatives, or an older child or adult who exacts a fee for using a corner of the sidewalk. A hierarchical system requires street workers and beggars to "rent" the corner where they work [PLATE 117]. Gangs and police may extort a child's earnings in exchange for safety or "permission" to beg.

In some cities, children line the streets to clean car windows or perform juggling acts when cars are stopped at red lights [PLATE 96]. They shine shoes [PLATE 95], or sell vegetables or fish [PLATE 106] or plastic bags [PLATE 103]. Children may also work in small market stands or set up their own gaming operation [PLATE 104]. In many cities boys sell newspapers. A young vendor may ride a bicycle with large stacks of papers strapped precariously to the carrying rack. One boy holds the papers steady while another jumps on the bicycle before the entire load tumbles.

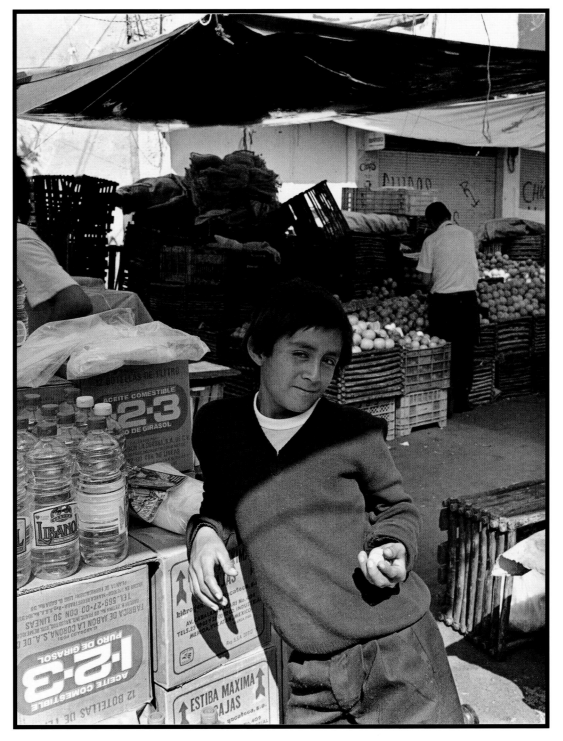

86. Market vendor, Mexico, 1992

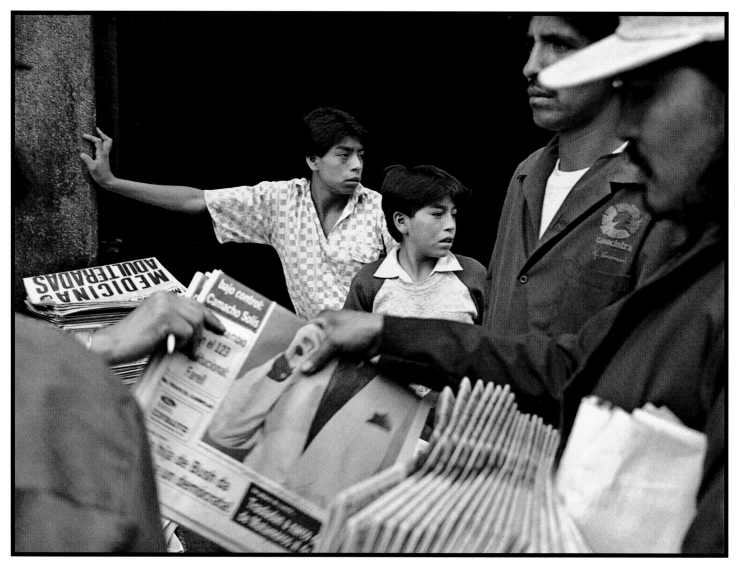

87. News vendors, Mexico, 1992

112

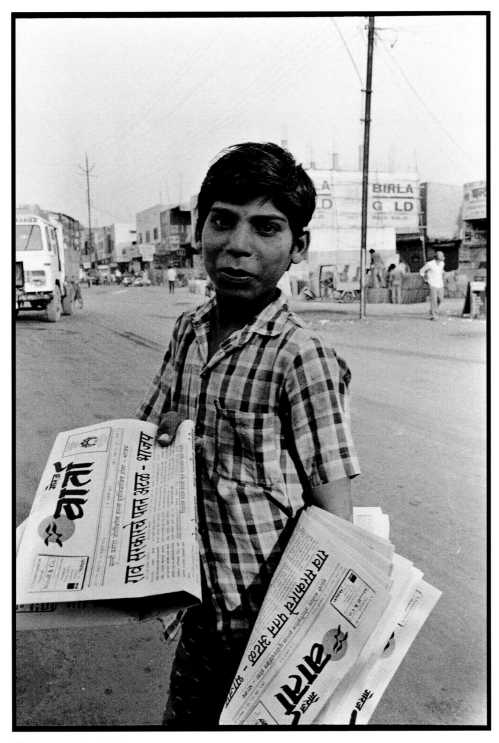

88. News vendor, India, 1993

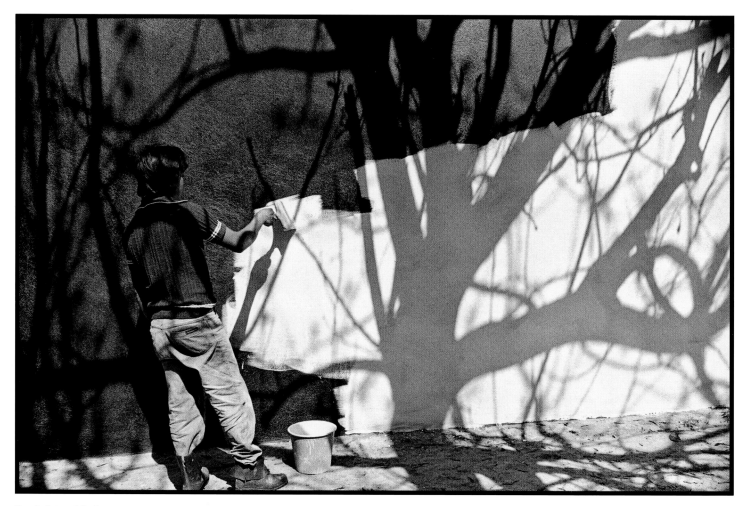

89. Painter, Mexico, 1992

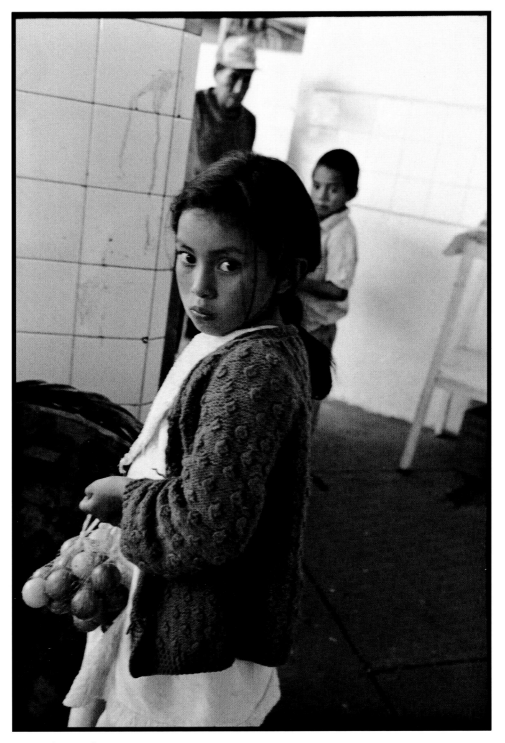

90. Market vendor, Peru, 1998

115

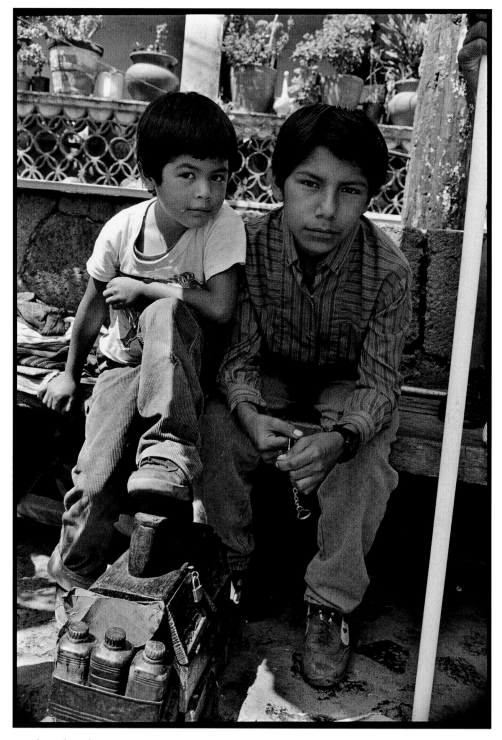

91. Shoe shine boys, Mexico, 1992

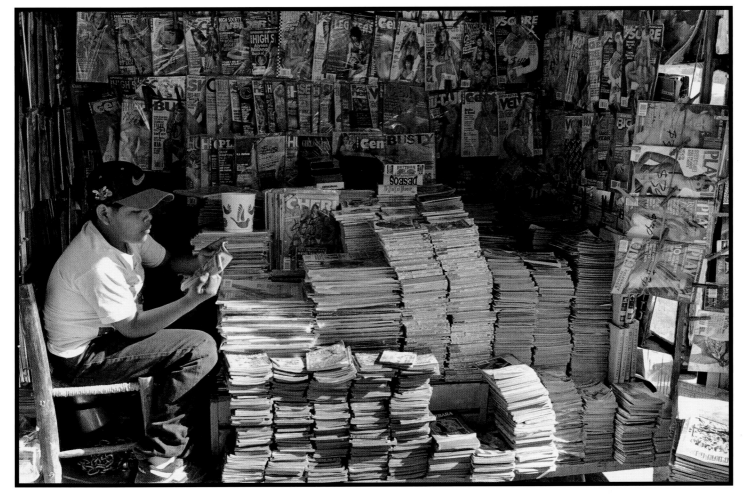

92. News and magazine vendor, Mexico, 1992

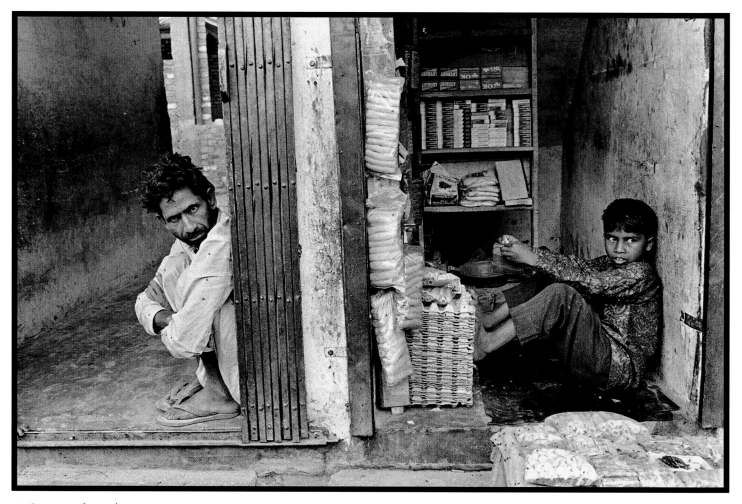

93. Street vendor, India, 1993

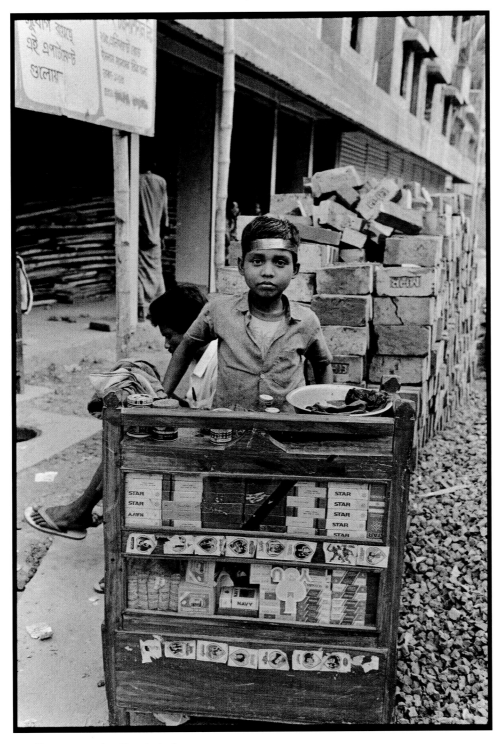

94. Cigarette vendor, Bangladesh, 1993

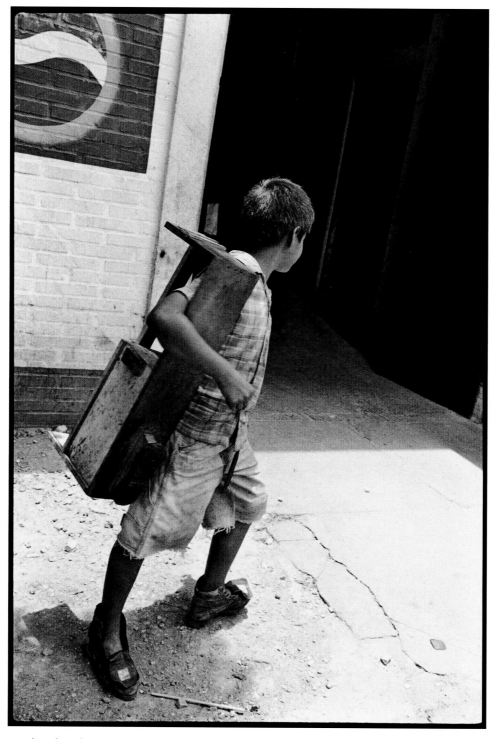

95. Shoeshine boy, Guatemala, 2001

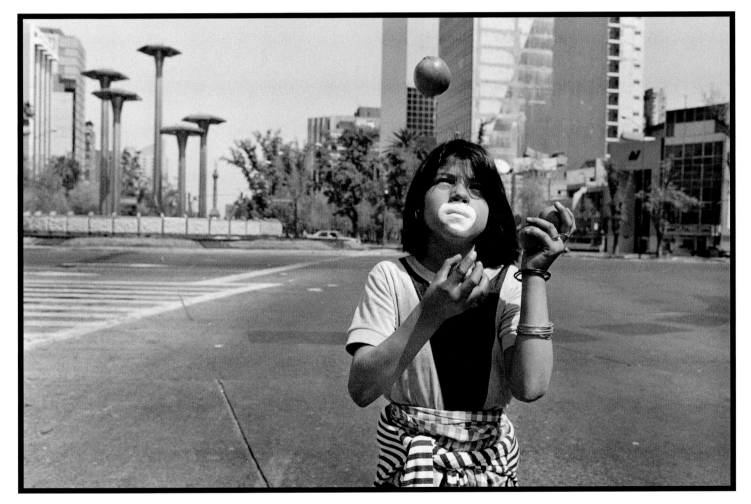

96. Street performer at a stop light, Mexico, 1992

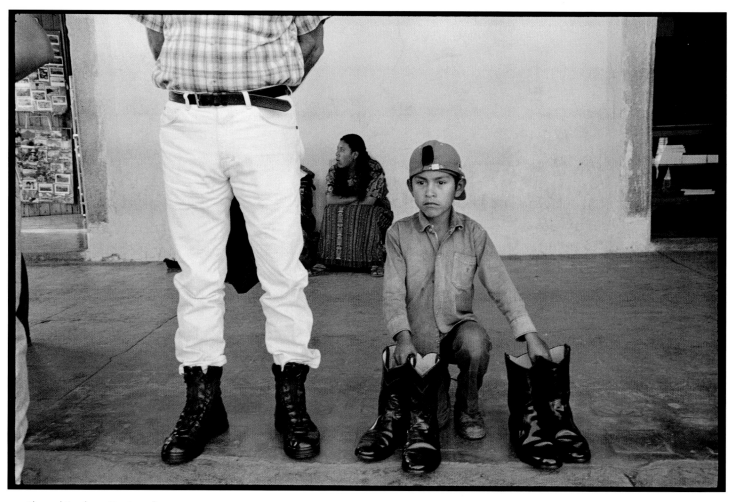

97. Shoe shine boy, Guatemala, 2003

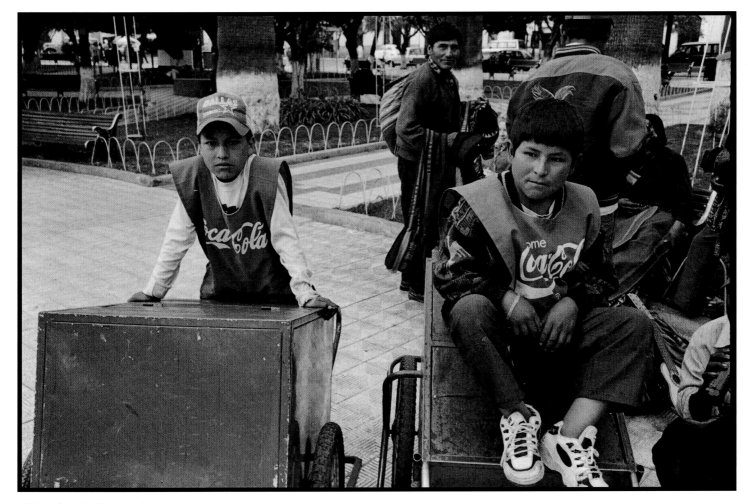

98. Vendors, Bolivia, 1998

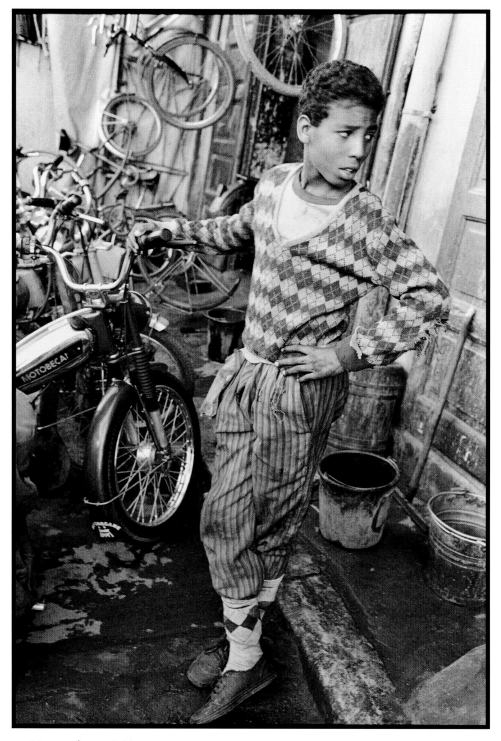

99. Motorcycle repair, Morocco, 1997

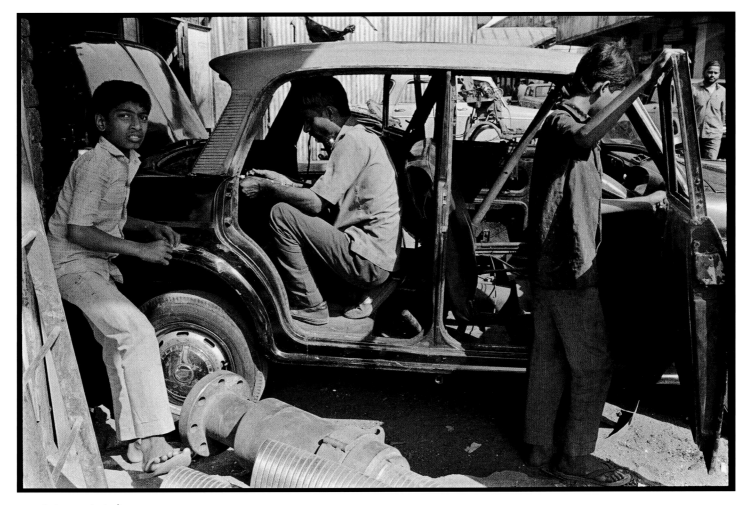

100. Auto repair, India, 1993

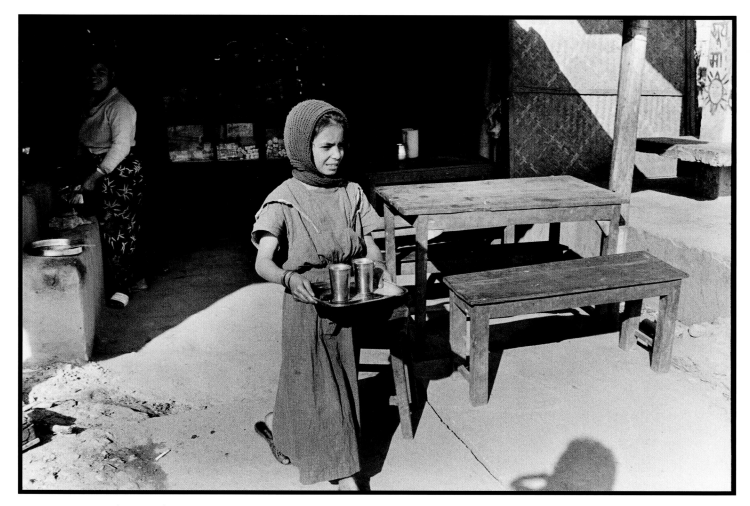

101. Restaurant worker, Nepal, 1993

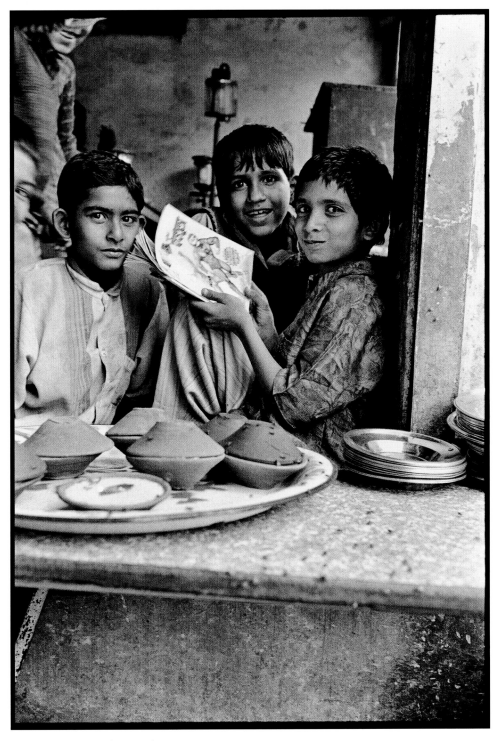

102. Restaurant workers, India, 1993

128

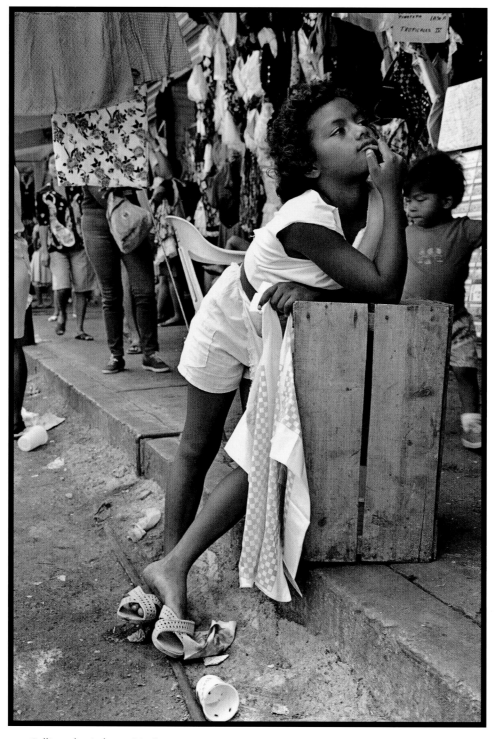

103. Selling plastic bags, Mexico, 1992

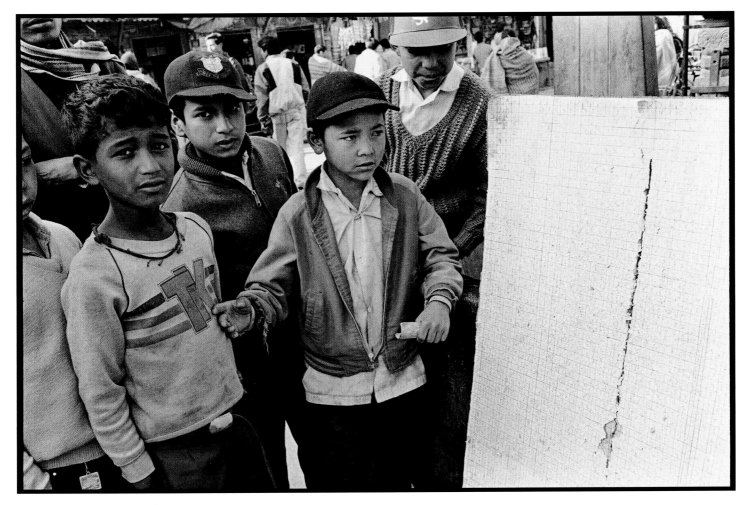

104. Street gamblers, Nepal, 1993

130

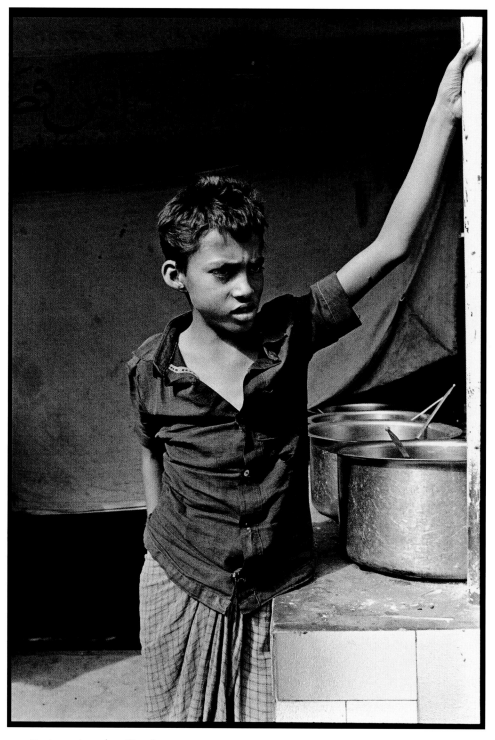

105. Restaurant worker, Nepal, 1993

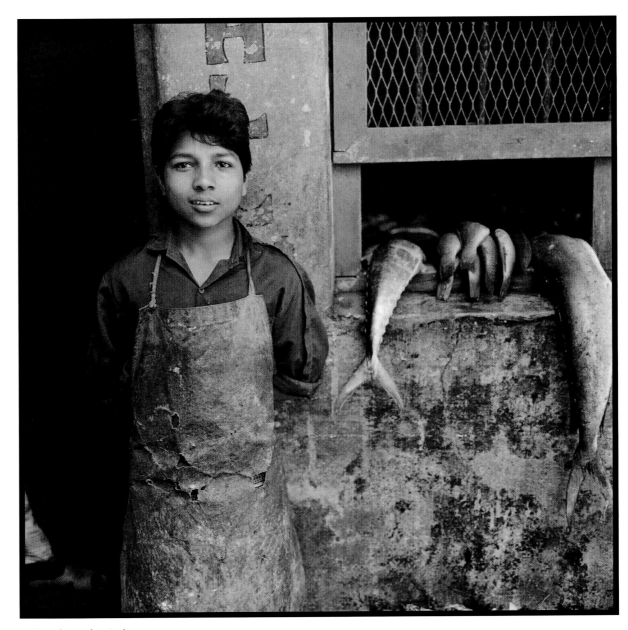

106. Fish vendor, India, 1995

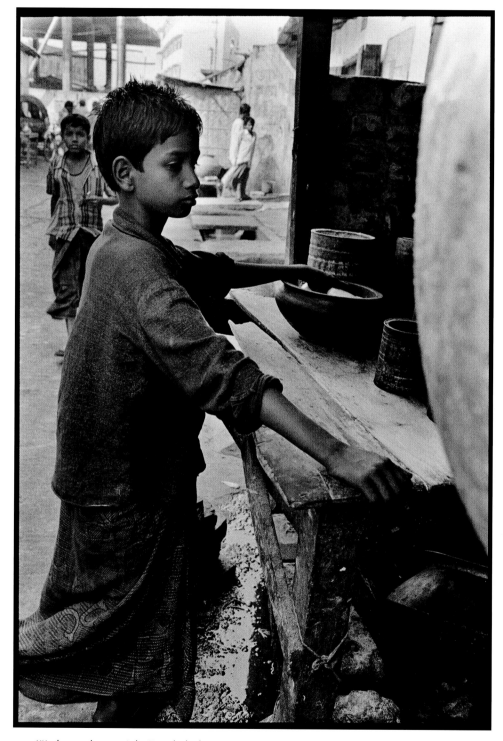

107. Worker, unknown job, Bangladesh, 1993

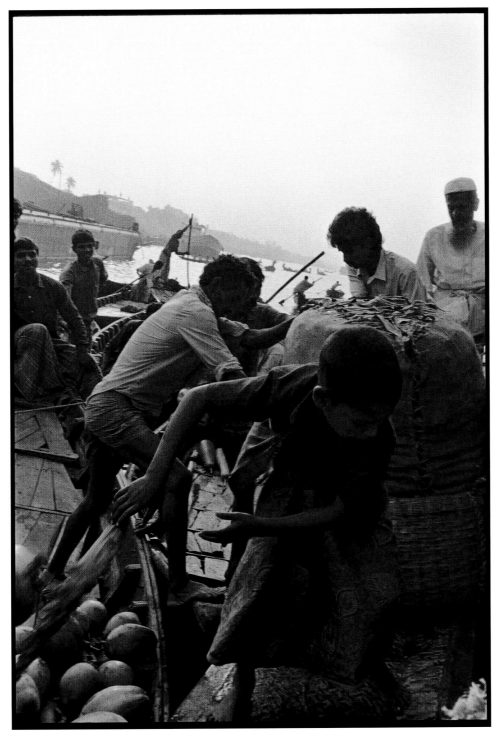

108. Dock worker, Bangladesh, 1993

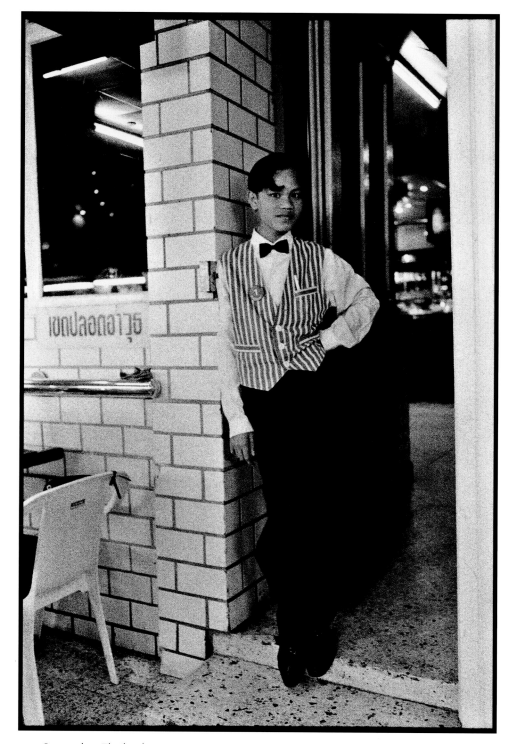

109. Sex worker, Thailand, 1993

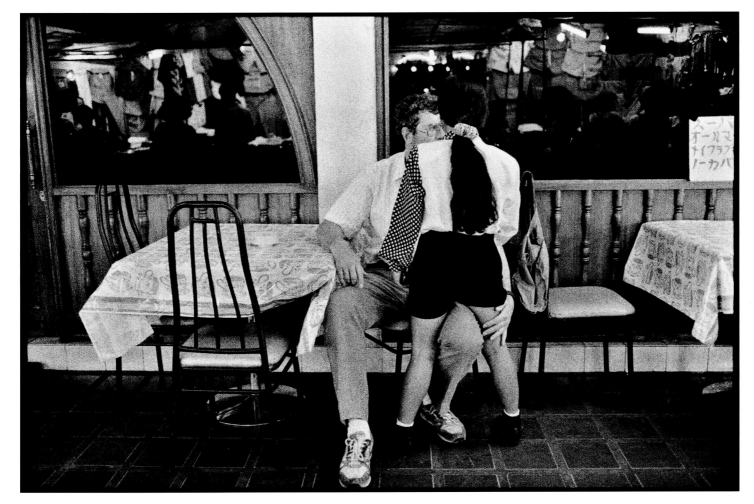

110. Sex worker with a tourist, Thailand, 1993

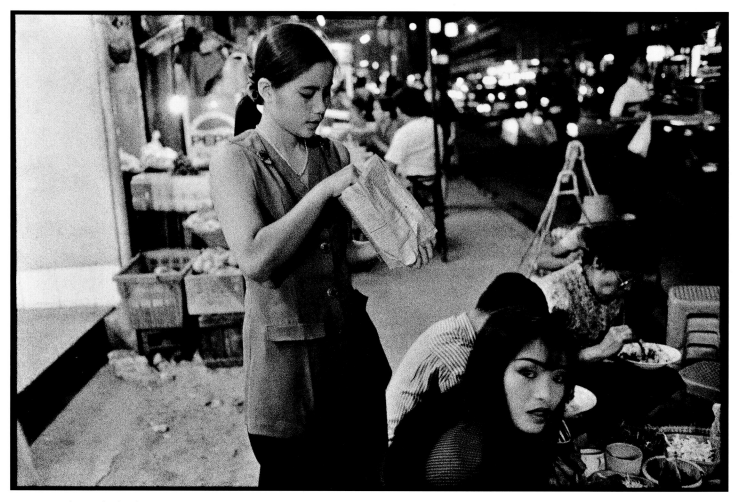

136

111. Sex workers, Thailand, 1993

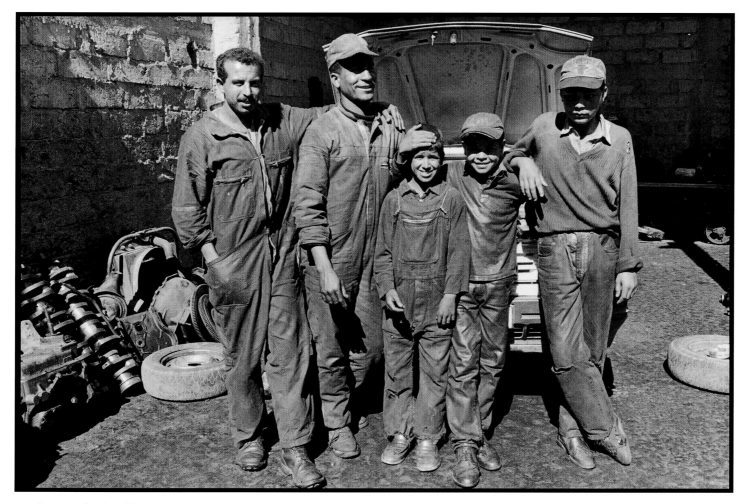

112. Auto mechanics, Morocco, 1997

I HAVE NEVER SEEN A PUBLISHED REPORT on the number of children or adults who work as garbage pickers around the world. Although it is impossible to obtain good estimates, based on even casual observation the number is likely high. People sort through rotting garbage in search of paper, wood, plastic, or other items to sell [PLATE 125]. As they search, the workers battle flies, vermin, and mangy, sometimes rabid dogs. People swarm over garbage as it is emptied from trucks. I have heard reports of children being buried alive in garbage.

Working conditions for garbage pickers are similar in most places. As described by social workers in Calcutta, "The condition of the scrap collector is very pathetic. They collect waste materials from the dustbins and from most shanty areas of the city. They appear in torn cloth with shabby dress with their gunny bags and sacks on their back."[17]

A report on child laborers in Delhi states that about half the children working as garbage pickers earned between 2 and 4 rupees a day, or about 6 to 12 cents.[18]

One of the larger dumps I visited was in Bekasi, Indonesia. Three thousand to five thousand families live and work on top of the garbage that is hauled from Jakarta. A family group earns $7 to $10 per week. During the rainy season, water-logged garbage cooks under the searing tropical sun. Animal carcasses, including dead rats, litter the dump.

Children forage for food in the rotting piles of refuse. Families set out their meals on mats in the middle of the dump. The only drinking water comes from a stream that runs through the garbage, and people build homes out of the old sheet metal and cardboard they can scavenge.

Some garbage pickers work on city streets. Commonly called rag pickers these children wander streets, bus stops, and rail stations with sacks hanging over their shoulders [PLATE 124]. They live on the street themselves or with their families on sidewalks.

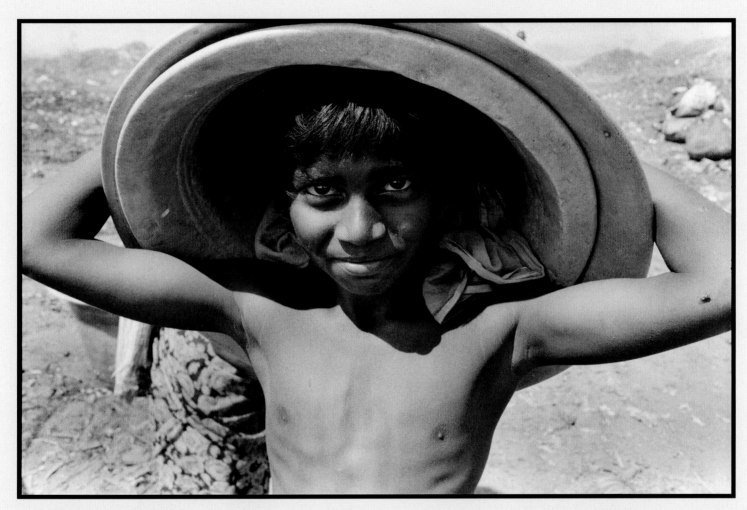

113. Garbage picker, India, 1995

GARBAGE PICKING
AND BEGGING

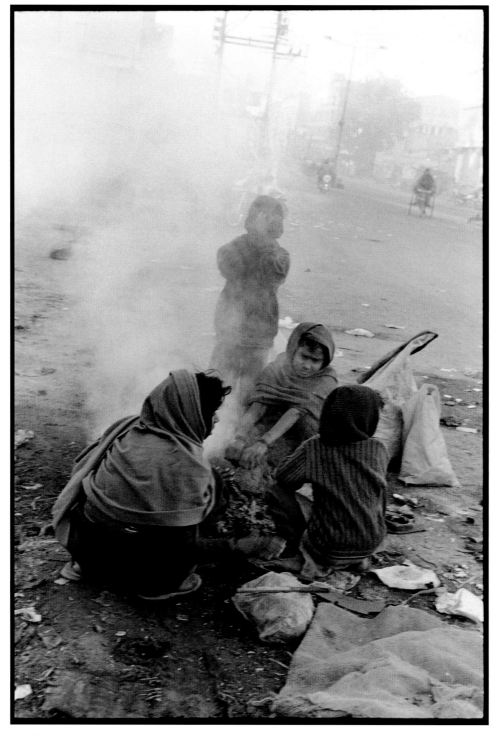

114. Garbage pickers, India, 2005

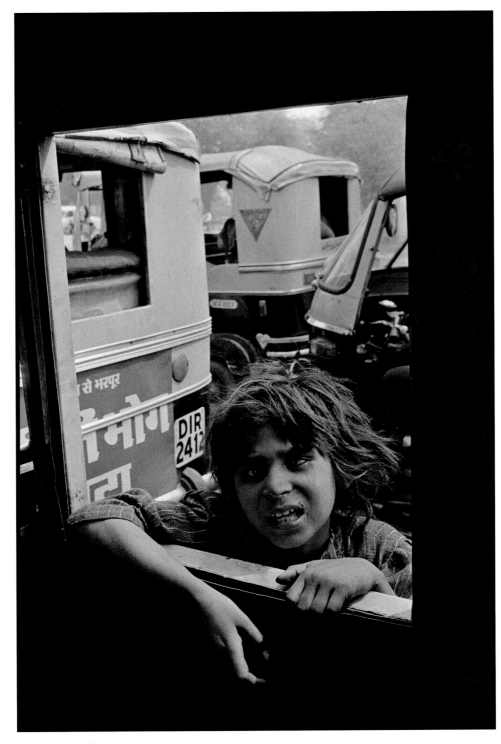

115. Beggar, India, 1993

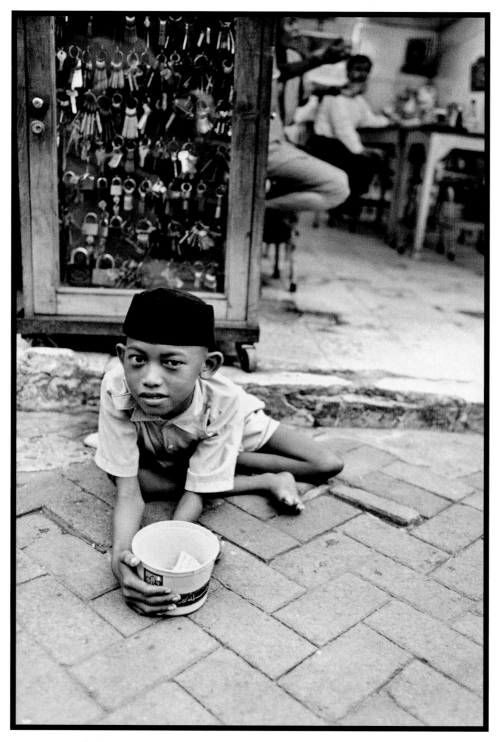

116. Beggar with polio, Indonesia, 1995

117. Beggars, India, 1993

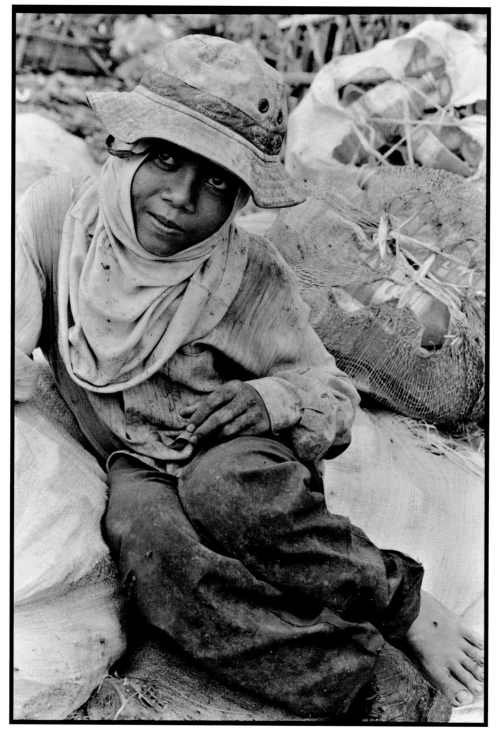

118. Garbage picker, Indonesia, 1995

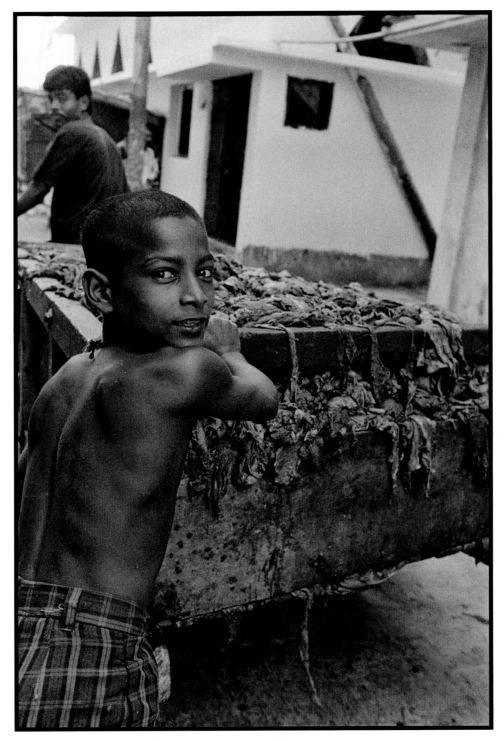

119. Hauling animal waste from a tannery, Bangladesh, 1993

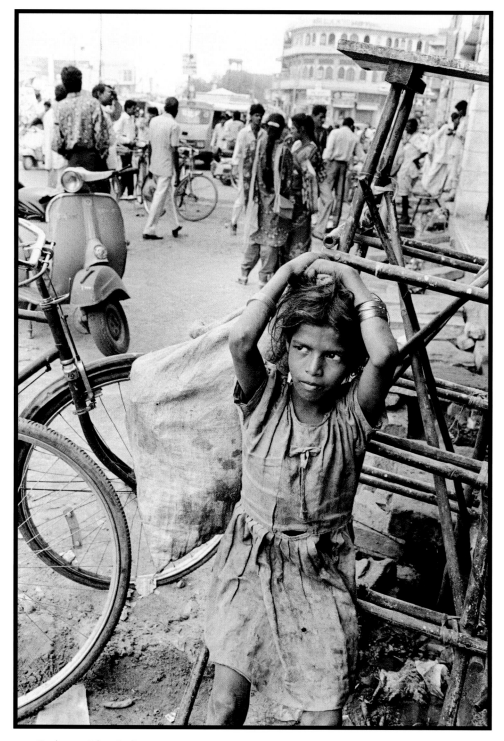

120. Garbage picker, India, 1993

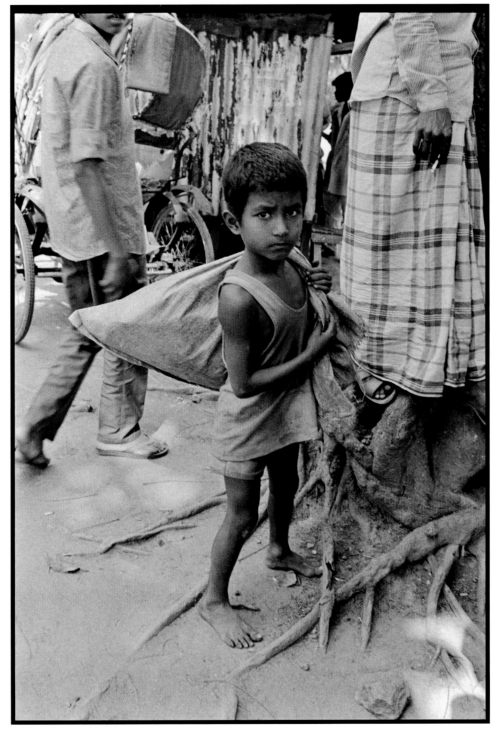

121. Garbage picker, Bangladesh, 1993

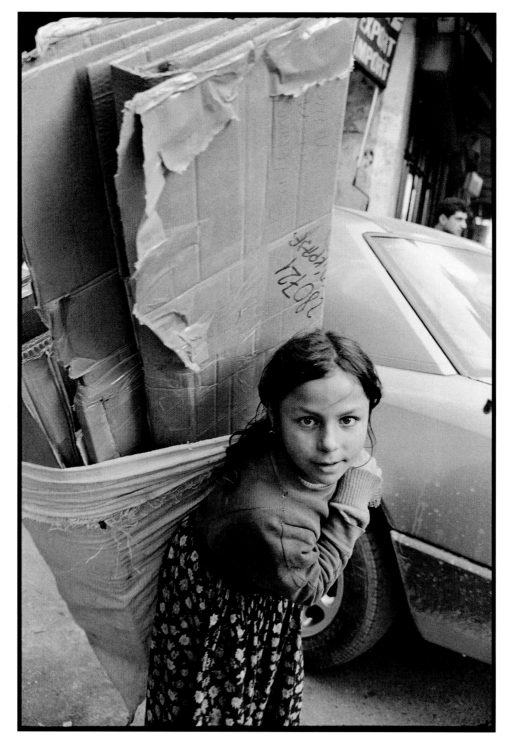

122. Scavenger, Turkey, 1997

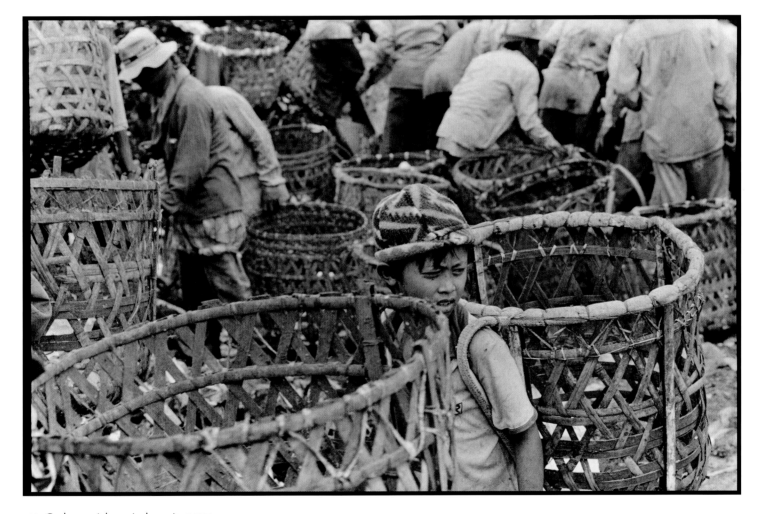

123. Garbage pickers, Indonesia, 1995

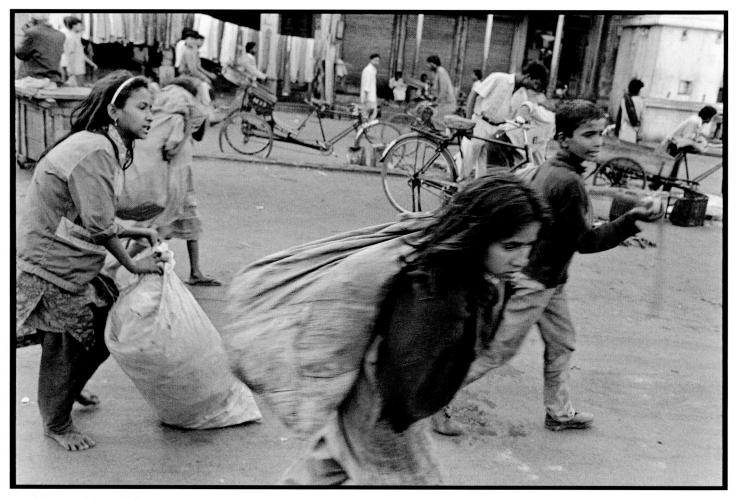

150

124. Garbage pickers, India 1993

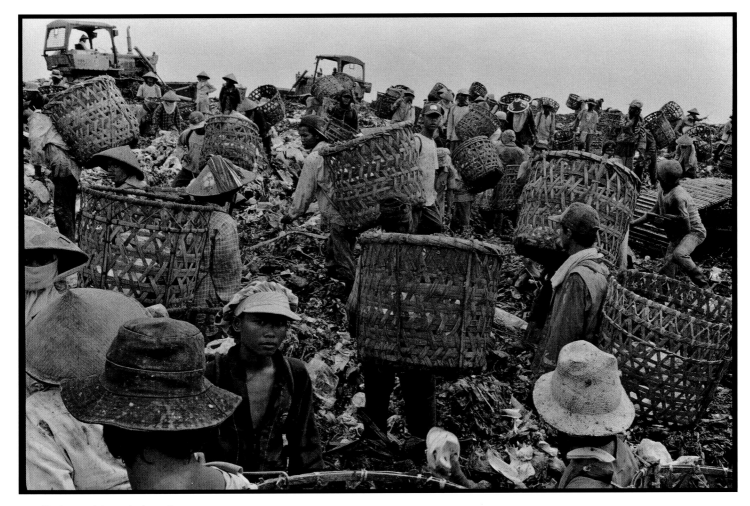

125. Garbage pickers, Indonesia, 1995

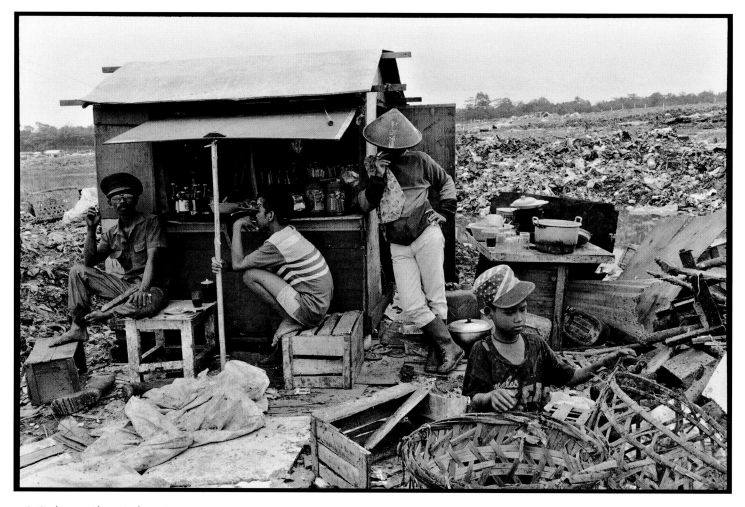

126. Garbage pickers, Indonesia, 1995

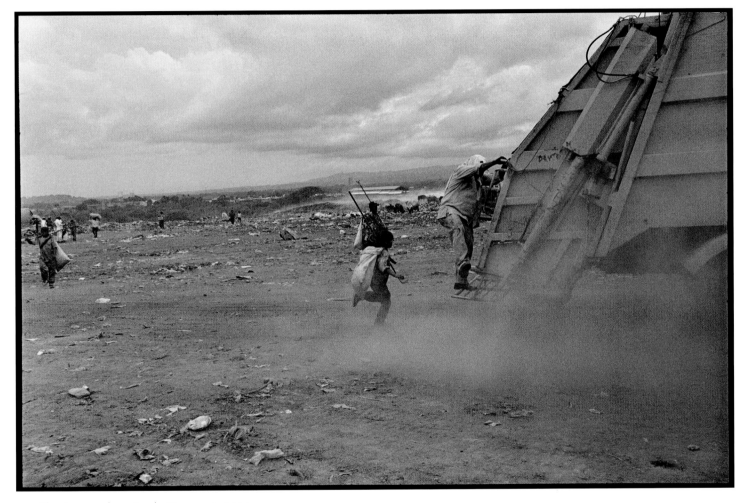

127. Chasing a garbage truck, Nicaragua, 2004

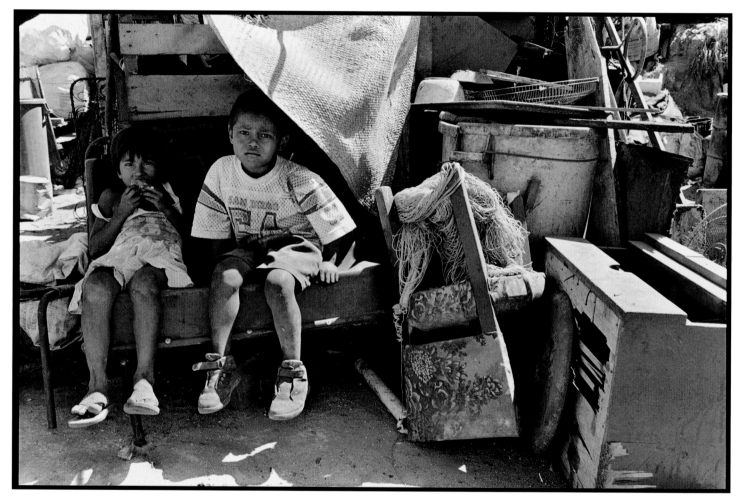

154

128. Garbage pickers, Mexico, 1996

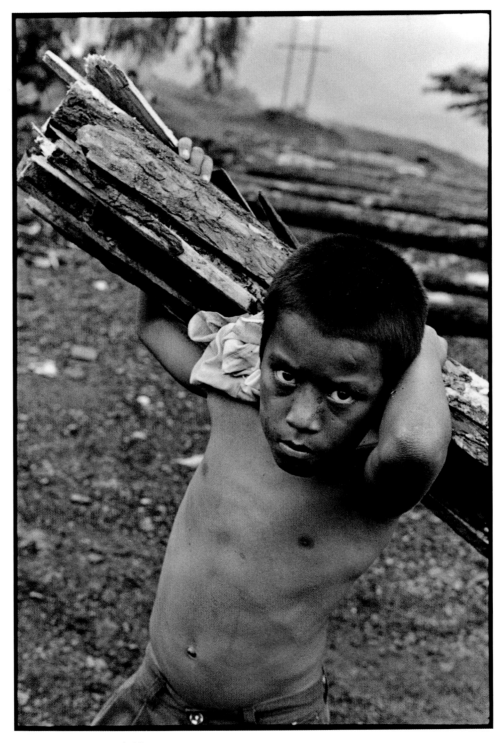

129. Scavenging wood, Nicaragua, 2004

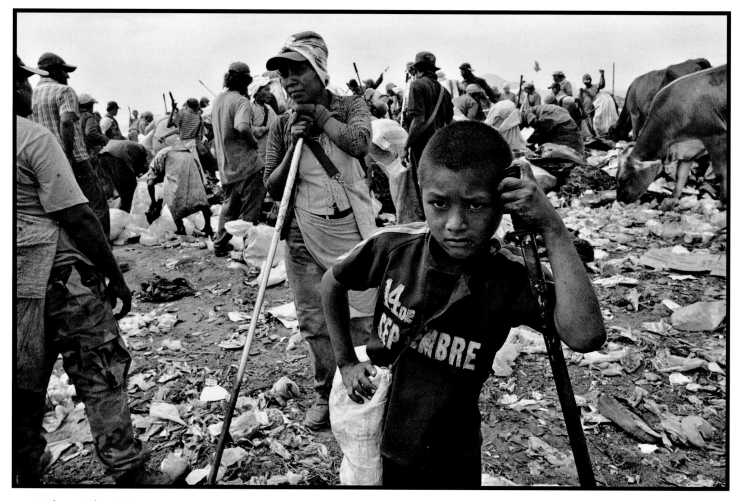

130. Garbage pickers, Nicaragua, 2004

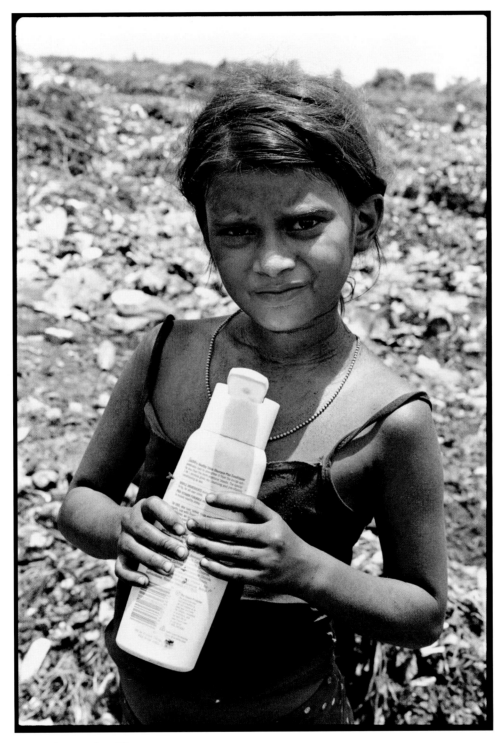

131. Garbage picker, Nicaragua, 2004

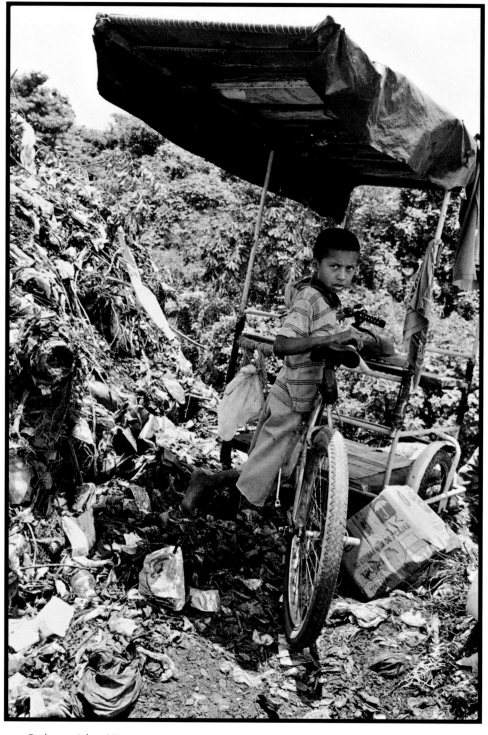

132. Garbage picker, Nicaragua, 2004

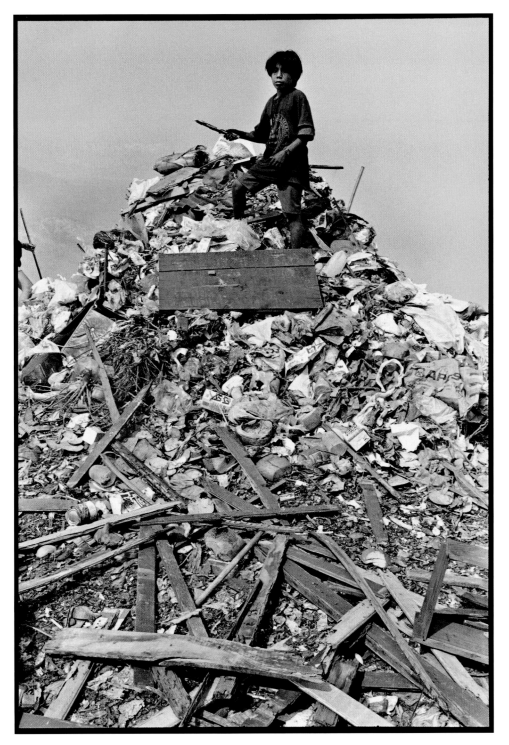

133. Garbage picker, Mexico, 1996

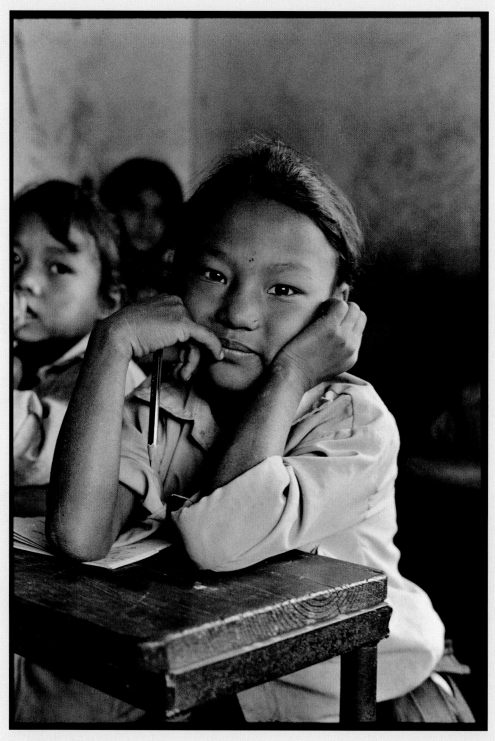

134. Schoolchildren, Nepal, 2005

ARESCUED CHILD WORKER IN INDIA WROTE, "My miserable tale is similar to other children working in stone quarries. I belong to the third generation of bonded labourers working in [the] stone quarries of Jharkhand. My parents were also born and brought up at the same place. I had seen life as 16 hours of rigorous work with scanty food that never satisfied my appetite."

Another child who was freed from bonded labor in brick kilns wrote, "My life is an example of believing that every unprivileged child, plagued with inhuman living conditions, is full of possibilities provided s/he receives *the* required training and guidance."[19]

For every child who is freed from forced labor and inhumane work, there are many more who continue to work. International and national laws have gone a long way in creating an awareness of child labor. However, it will take commitment on the part of all nations to eliminate the worst of its forms. This commitment must provide for the basic needs of children, families, and their communities. These needs include schools, food, books, and health care. The failure to control the AIDS pandemic continues to result in the displacement of millions of children. Many end up living and working on the street.

Perhaps the most common question I am asked is, "What can I do?" Many organizations, such as the Global March to End Child Labor, the National Consumers' League, and Anti-Slavery International, help child laborers. For example, Minnesota Advocates for Human Rights operates a small school in Sankhu village, on the outskirts of Kathmandu, Nepal.[20] The school serves poor children, who receive free schooling and a daily meal. Anyone can support these efforts by donating time and money.

THE FUTURE

NOTES

These references should guide most readers in finding research materials on child labor. Because Web sites change frequently, two excellent starting points for additional information are the International Labour Office and the United States Department of Labor, Bureau of International Affairs. I have made many public domain references available at childlaborphotographs.com. Readers can contact me via this site.

1. A copy of the Universal Declaration of Human Rights may be found at www.un.org/Overview/rights.html. Another site that includes the declaration in multiple languages is www.unhchr.ch/udhr/index.htm.

2. The health impact of child labor is discussed in *Public Health Reports*, volume 120, number 6, November–December 2005. See www.publichealthreports.org.

3. A discussion concerning the impact of child labor on the development of girls may be found in D.L. Parker and S. Bachman, "Economic exploitation and the health of children: Towards a public health model." *Health and Human Rights: An International Journal* 5 (2002): 93–119.

4. International Labour Office, "Bitter Harvest: Child labour in agriculture." ILO (Geneva, 2002). This can be downloaded in PDF format at www.ilo.org/public/english/dialogue/actrav/genact/child/part2_a/agric.htm.

5. Human Rights Watch provides an excellent discussion of migrant workers in the United States in its publication *Fingers to the Bone: United States Failure to Protect Migrant Farmworkers*. Human Rights Watch (New York, 2000).

6. International Labour Office, "The Burden of Gold: Child labour in small-scale mines and quarries." Found at www.ilo.org/public/english/bureau/inf/magazine/54/mines.htm. Accessed March 3, 2006.

7. Amalis Baron, "Potosí's silver tears." www.unesco.org/courier/2000_03/uk/dici/txt1.htm. Accessed March 18, 2005. Readers may also be interested in June Nash, *We Eat the Mines, the Mines Eat Us*. Columbia University Press (New York, 1993).

8. Alan Whittaker, "Children in Bondage: Slaves in the Indian Subcontinent." No. 10 in the *Child Labour Series*. Anti-Slavery International (London, 1991).

9. Although it is difficult to find information detailing the number of children working in different industries, the United States Department of Labor does an excellent job describing many forms of child labor in manufacturing. The department has published a series of reports entitled *By the Sweat and Toil of Children*. The reports are available at www.dol.gov/ILAB/media /reports/iclp/main.htm.

10. Anti-Slavery Society, "Child Labor in the Carpet Industry." www.anti-slaverysociety.addr.com/ carpets.htm. Accessed March 3, 2006.

11. UNICEF, *State of the World's Children: Excluded and Invisible*. www.unicef.org/sowc06/profiles/ street.php. Accessed August 3, 2006. UNICEF publishes a report each year called "State of the World's Children." These reports are an excellent source of global data on the health and educational status of children.

12. D.L. Parker, "Child labor and street children around the world." *Lancet* 360 (December 2002): 2067–71.

13. Human Rights Watch, "Easy Targets: Violence Against Children Worldwide." This report is available at www.hrw.org/reports/2001/children/.

14. Ibid.

15. International Labour Office, International Program for the Elimination of Child Labor, "Every Child Counts: New Global Estimates on Child Labor." ILO (Geneva, 2002). This document offers a wide range of statistical data on working children. Available at www.ilo.org/public/english/standards/ipec/simpoc/ others/globalest.pdf.

16. Maggie Black, "In the Twilight Zone: Child workers in the hotel, tourism and catering industry." ILO (Geneva, 1995).

17. Swapan Kumar Sinha, *Child Labour in Calcutta: A Sociological Study*. Naya Prokash (Calcutta, 1991).

18. Indian Council for Child Welfare, *Working Children in Urban Delhi: A Study of Their Life and Work*. Indian Council on Child Welfare (Delhi, 1977).

19. These stories were provided by the South Asian Coalition on Child Servitude. Information on SACCS is available at www.cridoc.net/saccs.php.

20. Minnesota Advocates for Human Rights may be contacted at hrights@mnadvocates.org.

ACKNOWLEDGMENTS

I would like to thank Dr. Jack and Kay Dunne, whose financial support and encouragement made this book possible. I'm also grateful for the financial support provided by the Park Nicollet Foundation, Diane Mull, and the International Initiative to End Child Labor. The children from Mukti and Balika ashrams in Delhi wrote their stories for use in this book. Lee Engfer assisted me with the text. Tom Arndt tirelessly encourages my work and has looked at every photograph I have ever printed. Peter Latner helped me with printing. Senator Tom Harkin was kind enough to write a foreword for the book as well as sponsor exhibitions of my work at the United States Senate. James Merchant, dean of the University of Iowa School of Public Health, also assisted with the foreword. Ted Hartwell, curator of photographs, the Minneapolis Institute of Arts, helped edit my photographs. María Ivette Fonseca guided my work in Nicaragua. Most of all, I thank my wife, Mary, who tolerated Minnesota winters when I was traveling in warm, if not always pleasant, places.

—DAVID L. PARKER